FRONTIER

Art and Treasures of the Old West from the Buffalo Bill Historical Center

AMERICA

FRONTIER

Art and Treasures of the Old West from the Buffalo Bill Historical Center

The Buffalo Bill Historical Center in association with
Harry N. Abrams, Inc., Publishers, New York

AMERICA

Text and Captions by Paul Fees and Sarah E. Boehme

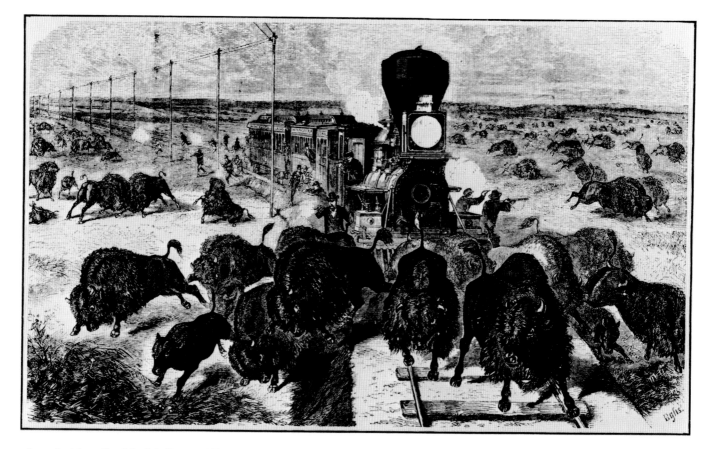

A woodcut from *Frank Leslie's Illustrated Newspaper*, 3 June 1871

Photography by Bob Weiglein

Project Director: Margaret L. Kaplan
Editor: Charles Miers
Designer: Darilyn Lowe

Half-title page: A buffalo hunted in
1892 by Lord Rendlesham and now part of the Boone and
Crockett Club's National Collection of Heads and Horns at
the Buffalo Bill Historical Center
Title page: Albert Bierstadt. *Island Lake, Wind River
Range (detail)*. See page 39

Library of Congress Catalog Card Number: 87–72421
ISBN 0–8109–0948–0
ISBN 0–931618–24–X (pbk.)

CONTENTS

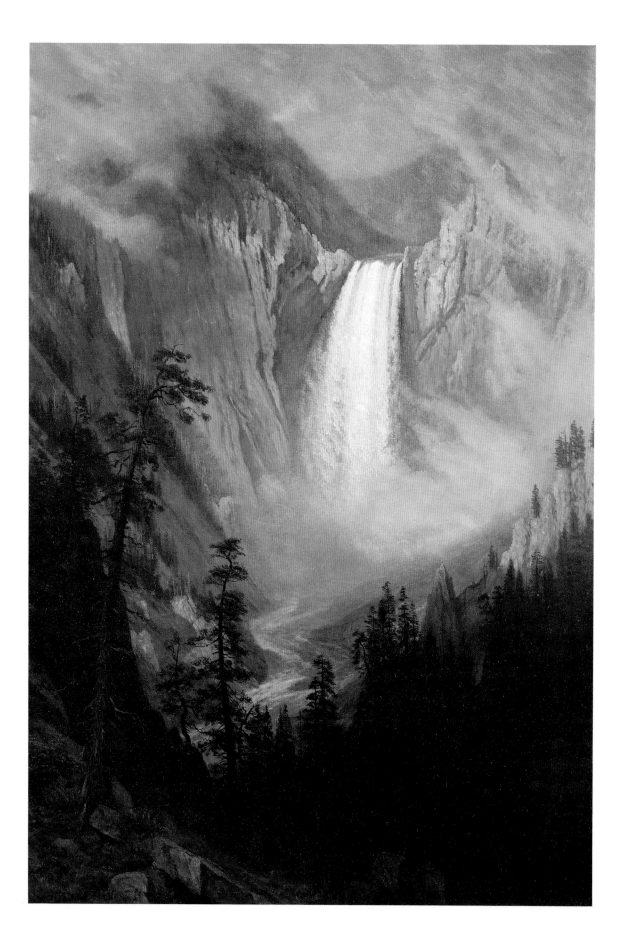

PREFACE

This volume is in large part the result of efforts by many individuals who do not work at the Buffalo Bill Historical Center. My special thanks are extended to the trustees of the Buffalo Bill Memorial Association (our legal entity) and to Morton Golden, Director; Katherine Plake Hough, Curator of Art; the Board of Trustees; and the Western Art Council of the Palm Springs Desert Museum, who supported and encouraged the development of the exhibition with which this publication is associated.

Without the hard work and professional dedication of the Buffalo Bill Historical Center staff, however, this volume would not have been possible. I especially commend the efforts of Sarah E. Boehme, John Bugas Curator at the Whitney Gallery of Western Art, and Paul Fees, Curator of the Buffalo Bill Museum, for the insights presented in their essays and for their careful review of the art and history collections of the museum. When their work was joined with selections by George Horse Capture, Curator of the Plains Indian Museum, and Herb Houze, Curator of the Winchester Arms Museum, the basis for the book and the exhibition was established. Special thanks also go to Bob Weiglein, whose photographs enhance this volume, and to Melissa Webster, Shari Small, Karen Krieger, Teresa Robertson, Sylvia Huber, and Patti Guill, who worked on elements of the exhibition and catalog.

Mrs. Henry H. R. Coe
Chairman of the Board
Buffalo Bill Memorial Association

ALBERT BIERSTADT
(1830–1902)
Yellowstone Falls
1881. Oil on canvas, 44¼ × 30½"
Gift of Mr. and Mrs. Lloyd Taggart
2.63

INTRODUCTION

O nce, some seven or eight generations ago when practically all of America was a frontier, a fledgling museum in the burgeoning cultural center of Philadelphia fashioned a wonderfully ordered view of the world for its visitors. The galleries were referred to collectively as Peale's Museum, and as part of their sectioned displays (or Linnean compartments) they proudly assembled the several components of that grand puzzle, the cosmos.

What Mr. Peale's museum provided for its bewildered though eager audiences was not a finite view of the universe, but rather a broad picture of the manifold facets of human interest in the order of the world. Combining the fields of art and history and science, the museum charmed, educated, and enriched native and foreign visitors through a potpourri of Americana. The museum's guests were invited to see and enjoy not an art exhibition nor a history lesson nor a science demonstration but rather a union of those forums, each sharing in equal measure with the other to provide a window on the world and to reveal the essence of the developing American experience.

The propensity for such eclectic acquisitions has found less favor with recent generations of museum professionals. But, out of respect for the Peale tradition, there is at least one museum, the Buffalo Bill Historical Center in Cody, Wyoming, that presents itself, its collections, and its programs in that spirit. Since the Cody museum is physically adjacent to one of the world's most exquisite natural exhibits, Yellowstone National Park, it has chosen to focus on the humanities as a complement to the natural sciences so handsomely revealed in that wilderness preserve. With a mandate to represent human activity during the settlement of the frontier, the Buffalo Bill Historical Center draws on a broad range of disciplines to preserve the West's image, its iconography, and its historic worth.

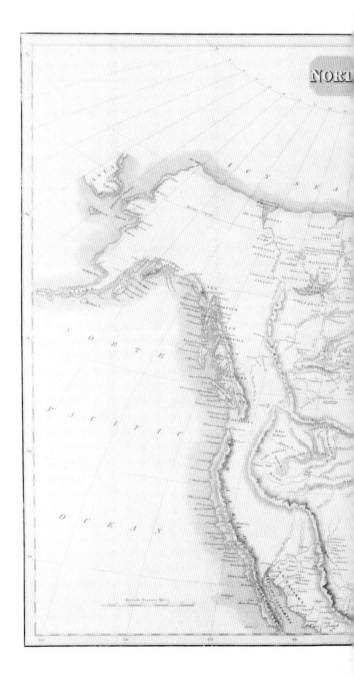

N. R. HEWITT
North America
1814. Engraving on paper, 23½ × 19½"
From John Thomson's New General
Atlas
1.69.2414

One of the first published maps of
North America to include the findings of
Lewis and Clark.

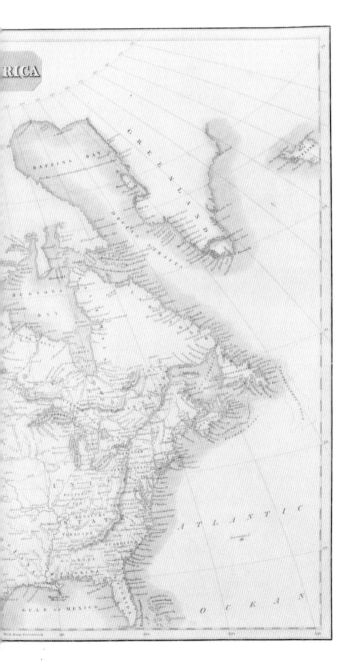

Spoils from the past have always made good history, and if they are human in origin and scale they express time in a way that allows people to relate to bygone epochs. Though literature has traditionally been given the credit for preserving history, the study of art and objects have long rivaled its claim. Rarely these days, however, are art, material culture, and literature joined equally in celebration of history. As disciplines they have kept their distances, presumably for the sake of maintaining the integrity of each. Yet, common ground for the union of these three forces was laid in the American experience in 1803, shortly after Peale founded his museum, when Lewis and Clark bridged the Mississippi and confronted the Far West. They returned from their odyssey with reports and evidence of an immense land spilling over with untapped riches and teeming with people and animals. From this genesis unfolded one of the most colorful and dramatic chapters in American history—the frontier saga.

George Catlin, a Philadelphia-trained artist, followed the path of Lewis and Clark up the Missouri thirty years later. He too proclaimed the epic scale of America's West: "No man's imagination, with all the aids of description that can be given to it, can ever picture the beauty and wildness of scenes that may be daily witnessed in this romantic country." Catlin spent eight years compiling his renowned Indian Gallery, which ultimately comprised over six hundred paintings of Western life and countless Indian objects. To set these two segments of his collection in perspective, he prepared copious annotations, published first in London in 1841 as *Letters and Notes on the Manners, Customs, and Conditions of the North American Indians.* Thus, in one man's work—an extraordinary individual effort—were wed the energies of art, ethnology, and literature.

Throughout the nineteenth century, artists and explorers followed Catlin's lead, reaping a harvest of mementoes before the passage of time could put memories beyond reach. By the end of the century, when the frontier "closed," the Western saga found ample expression in the nation's arts and literature as well as through an array of collected material objects. William F. "Buffalo Bill" Cody, with his Wild West extravaganzas, then carried the spirit of Catlin's project to a popular conclusion, in which Western myth and history, enveloped in a swirling cloud of dramatic visual display, gained a world audience.

In Cody, Wyoming, on July 4, 1927, the original Buffalo Bill Museum was dedicated. It was a log building, fashioned after Cody's TE Ranch house, which held his collections of art and objects of the Old West. Today, just across the street from

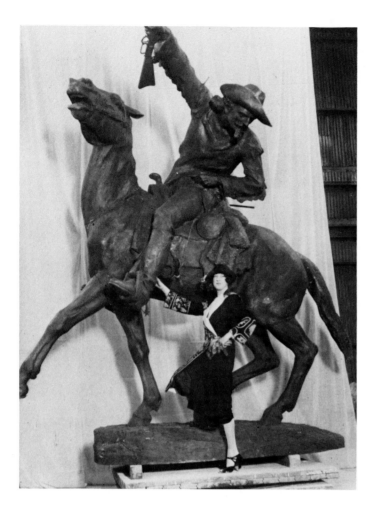

the old museum, stands the Buffalo Bill Historical Center, an elaborate and inviting complex that for more than two generations has been devoted to preserving and presenting America's bountiful Western heritage. Balancing the disciplines of art and history and literature, the museum recognizes both the realities and myths of the West as determining forces in our national history and in our daily lives.

The Buffalo Bill Historical Center consists of four major museums in one. The Buffalo Bill Museum, which moved into its present facility in 1969, houses the most extensive assemblage of Buffalo Bill material in the world. Its collection also addresses Western history in general. The Whitney Gallery of Western Art, built in 1959 with a grant from the Gertrude Vanderbilt Whitney Trust, features a rich collection of masterworks of American painting and sculpture, both contemporary and historic, pictorially celebrating the enduring image of the western frontier. The Plains Indian Museum, opened in 1979, is devoted to the

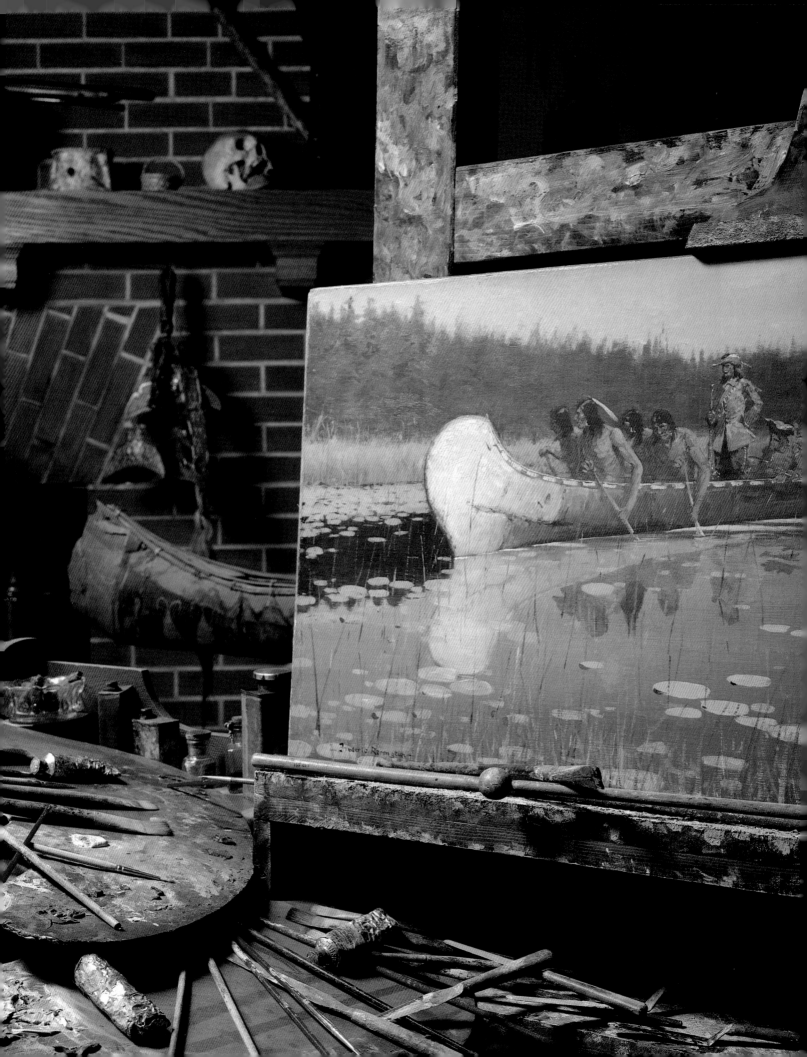

beauty and traditions of Native American life in the West. And the Winchester Arms Museum, stemming from a collection begun by Oliver Winchester in the 1860s, came to Cody in 1976 from the Winchester Group, Olin Corporation, of New Haven, Connecticut. It contains the world's largest array of American projectile arms.

This volume takes stock of the remarkable blend of materials and disciplines housed in the Cody museum. With the rich diversity of objects held in trust by this institution, many insights about the West and its people can be revealed that would otherwise remain obscure or hidden. Using this store of treasures, the authors of this volume have shed new light on America's national identity, the power of unifying symbols, and the course of American art as it was influenced by the wilderness experience.

It is written that history exists as a force because it is created here and now. The challenge for a museum is to utilize the materials of the past to actualize experience, to assist a society in rediscovering and developing its ability to respond to itself. Like Peale's Museum two centuries before, the Buffalo Bill Historical Center has endeavored to meet that challenge. In providing a brilliant chronicle of the frontier, the Cody museum establishes a union between the past and present, personally involving its visitors with the relics of their past. Reflected in the art and artifacts are the restless impulses that once possessed this nation and moved it westward as well as the timelessness of our artistic and native heritage.

Peter H. Hassrick
Director
Buffalo Bill Historical Center

Remington's studio as it has been reconstructed in the Whitney Gallery of Western Art.

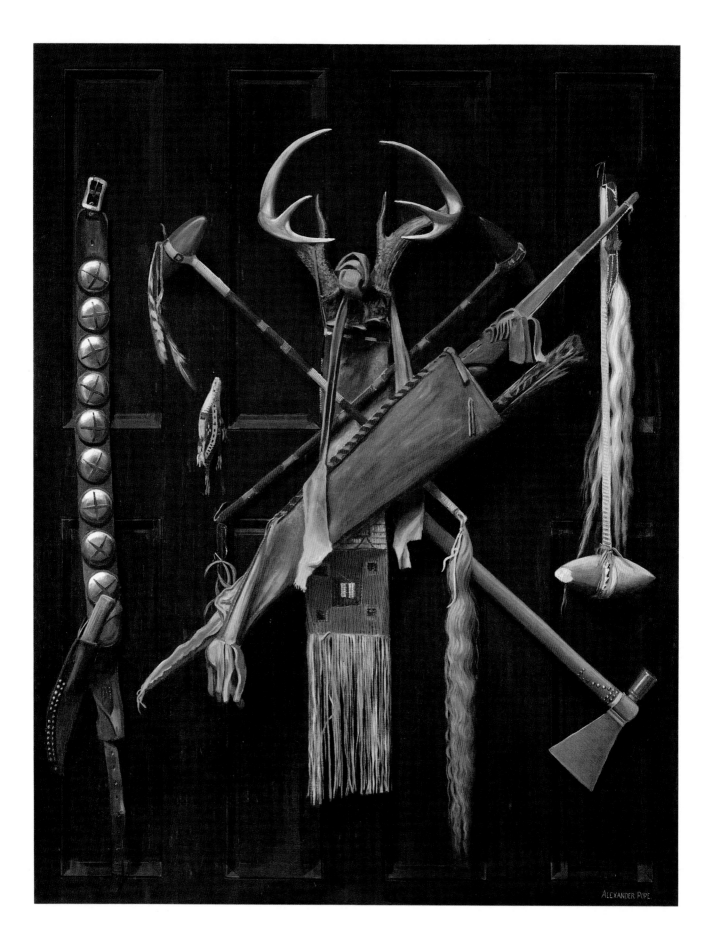

FRONTIER AMERICA: THE ARTISTS' ENVIRONMENT

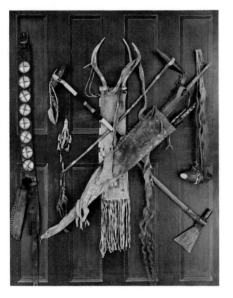

ALEXANDER POPE
(1849–1924)
Weapons of War
1900. Oil on canvas, 54 × 42½"
201.69

A trompe l'oeil artwork literally attempts to fool the eye. A comparison of *Weapons of War* (*left*) with the objects (*above*) reveals the effectiveness of the illusion. This type of painting is usually a still life because objects can be represented easily in their real size and because there is no need for movement to be depicted.

The unknown and often forbidding environment of the American West seems an unlikely place for the fine arts to have flourished. The physical dangers, the lack of amenities, and the absence of a cultural tradition were all barriers that would appear to have blocked the refined process of art. Yet, the American West provided challenges that required pictorial solutions. The unknown territory needed to be documented and pictures were needed to represent what the eye could see, especially because what could be seen could not always be comprehended. In the process of making pictures artists came to know this unfamiliar land and its contents. Almost as quickly as the West was becoming known, however, it was changing. Preserving the West therefore became another challenge for artists, whose pictures could save the appearance of the land and its history. And, as the West came to be perceived as an arena for conflict between man and nature or between other opposing forces, artists gave visual expression to the themes of opposition and danger. In their paintings and sculptures, they created a pantheon of heroic figures out of the individuals and types they portrayed (such as the cowboy taming a bucking horse or the cavalryman patrolling the Plains).

In order to tap sources of patronage, artists who confronted the challenges of the West found ways to make their art useful, a process which in turn influenced the kind of art they made. In a country where the dominant culture lacked a strong artistic tradition, the artists of the West infused a repertory of subjects into the developing culture and created distinctly American idioms, which attracted a broad audience to their work.

Since their profession lacked social legitimacy, aspiring American artists often needed to characterize their occupation in new ways and to create a special aura for

themselves and their art. The artists who served as documenters of the frontier or illustrators of the old West defined their work in terms of its informational usefulness. This affected the way their art was perceived. Often it meant that the artist himself experienced a dilemma in presenting his work: if he wished an artwork to be esteemed, its functional purpose had to be emphasized, which in turn could detract from its chances of being regarded as fine art. Moreover, since Western art began within the tradition of documentation and was valued for the information it provided, that information was worthwhile only if it was accurate. Thus, from the earliest days of the frontier, artists of Western subjects emphasized the authenticity and accuracy of their images.

As one way of demonstrating accuracy was to focus on the replication of Western objects, artists have usually interacted not only with the space but also with the objects of the West to create their works. For although the West is a place, it is also embodied in things. Particular objects signify the West: the buffalo robe, the warbonnet, the revolver are common examples. Artists and their patrons avidly collected such artifacts, for they authenticated and evoked the experience of the West. Bits and pieces of the frontier were frequently arranged in an artist's studio for creative inspiration. Artists' studios have, of course, traditionally been stocked with objects of inspiration, but for artists of the American West the need for "the real thing" was especially strong. An example of the intensity of this emphasis is seen in Alexander Pope's painting *Weapons of War (page 14)*, which depicts an arrangement of American Indian objects. Finished in 1900, *Weapons of War* dramatically presents the Western object, painted illusionistically. The painting thus engages the viewer in a confrontation of truth and art. Such a painting could exist only after earlier artists had defined the frontier and established an easily recognizable iconography of Western subjects. The viewer had to have enough knowledge of the depicted objects to recognize them, otherwise there could be no illusion. For *Weapons of War* to have an impact on its audience, the type of objects portrayed in the painting first had to be experienced in their original context, the frontier.

For the early documentary artist, who had to present himself as an authority on the West, a way of guaranteeing his works' authenticity was to prove that he was an eyewitness to historical events or that he had specialized knowledge of frontier life. The itinerant artist James Otto Lewis carved a niche for himself by painting portraits of the Indian chiefs who gathered at treaty conferences to forge agreements with the

Lewis painted a portrait of Kee-o-Kuck at Prairie du Chien in 1825. This leader of the Sauk and Fox was later the subject of portraits by Charles Bird King, George Catlin and John Mix Stanley. Thomas L. McKenney and James Hall wrote of him, "Possessing a fine person and gifted with courage, prudence and eloquence, Kee-o-Kuck soon became the chief warrior of his nation, and gradually acquired the direction of civil affairs."

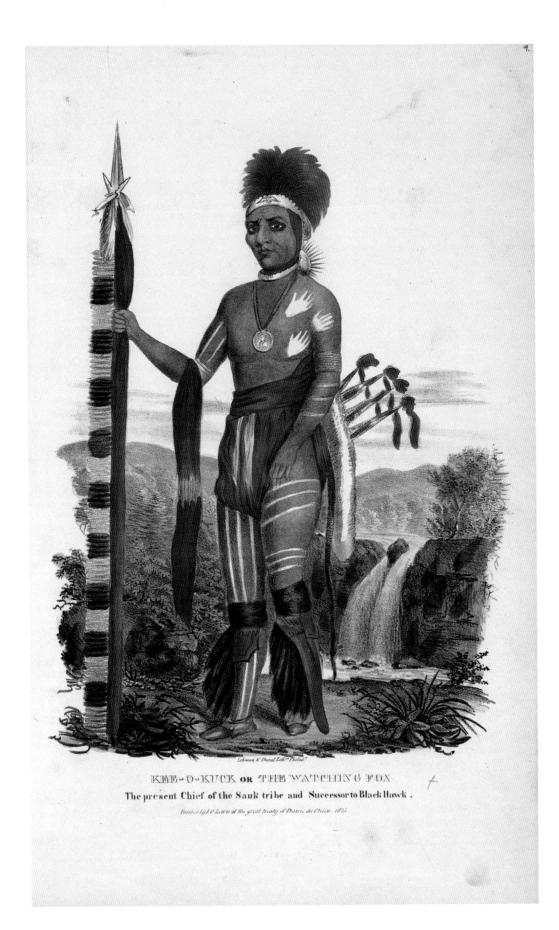

KEE-O-KUCK OR THE WATCHING FOX

The present Chief of the Sauk tribe and Successor to Black Hawk.

Painted by J. O. Lewis at the great treaty of Prairie du Chien 1825.

United States government. Lewis worked for Thomas L. McKenney, the superintendent of the Bureau of Indian Trade and later the first head of the Office of Indian Affairs, who guided American policy toward the Indians in the early nineteenth century. In his office at the Department of War, McKenney established the Archives of the American Indian, which included artifacts of Indian life and can be considered the first museum devoted to the Indian people. As part of his efforts to record Indian history, he began in 1822 to commission portraits of Indian chiefs who came to Washington as members of official delegations. To obtain portraits straight from the frontier, McKenney commissioned Lewis to attend treaty conferences. Lewis sent back watercolors to McKenney for his gallery, but he also found another way to market his art. He engaged the Philadelphia printers Lehman and Duval to make hand-colored lithographs after his works, which he published privately as *The Aboriginal Portfolio* in 1835 (*page 17*). Rather than printing the entire series at one time, however, he issued groups of prints at intervals, having solicited subscribers who would agree to purchase each set (or "number"). The subscription method, which was not uncommon, allowed the artist to collect funds for the project as it proceeded.

When Lewis advertised the first number of his publication, he pointed out that his series of Indian portraits was the "first attempt of the kind in this country." He also noted the difficult conditions under which he operated—"the great and constantly recurring disadvantages to which an artist is necessarily subject, while traveling through a wilderness"—and he opined that his works would be open to criticism. He hoped, however, to secure "the approbation not only of the critic, but of the connoisseur."

Lewis's use of the words "connoisseur" to refer to his audience and "artist" to refer to himself are examples of his efforts to define his works as fine art and not just as historical documents. In fact, he had had some training as an artist and had worked as an engraver in Philadelphia before going West. He also seems to have studied the works of the portrait painter Chester Harding. From lithographs made after Lewis's works, it appears that he could create striking, if crude, images.

Although Lewis appealed for his lithographs to be considered artistic, he took pains to have them valued as authentic documents of Indian life as well. He requested an endorsement from Lewis Cass, who had served as a government agent at the councils. A knowledgeable witness, Cass furnished proof of something that the purchaser could not

CHARLES BIRD KING
(1785–1862)
Naw-Kaw (published in The Indian Tribes of North America
by Thomas L. McKenney and James Hall, Philadelphia: 1837–1844)
Lithograph, 20½ × 14¼"
Gift of Clara S. Peck
42.70.14

King painted Naw-Kaw (meaning "wood") in Washington, D.C., probably in 1828 when the Winnebago delegation came to that city. Although the original King portrait did not survive a fire at the Smithsonian, the image exists in this lithograph and in a painted copy by Henry Inman, which is now in a private collection on loan to the Buffalo Bill Historical Center.

Bodmer included his self-portrait in this scene of European voyagers greeting the Minnetarree Indians. The young Swiss artist stands to the left of Prince Maximilian of Wied-Neuwied, the Austrian naturalist and explorer, who is being introduced to the Indians at Fort Clark. The extraordinary watercolors Bodmer produced on his journey to the West were published as aquatints to accompany Maximilian's text for *Travels in the Interior of North America.*

otherwise know—that the portraits were faithful. "It affords me great pleasure," he wrote, "in conformity with your request, to express my opinion of the fidelity of the execution of the Indian portraits which you have transmitted to me in your *Aboriginal Portfolio.*" The letter was printed on the cover of later numbers of Lewis's work, which initiated a long-standing practice of having a certificate of authenticity supplied with portraits of Indians.

In his original plan for the portfolio publication, Lewis intended to include only the pictures. He felt that the visual interest of his portraits would attract buyers, but he quickly came to the conclusion that his images could not stand alone. They required an accompanying text to appeal to the public. By the second number of the first edition, he was planning to add biographies.

In this venture, Lewis was in competition with his former employer, Thomas L. McKenney, who also produced a publication of Indian portraits. McKenney decided to have lithographs made of the gallery of Indian portraits he had commissioned for his office. Between 1836 and 1844, he published a three-volume set entitled *History of the Indian Tribes of the United States with Biographical Sketches and Anecdotes*

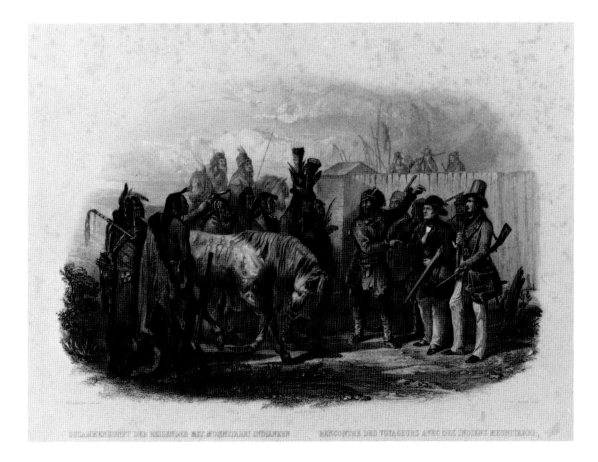

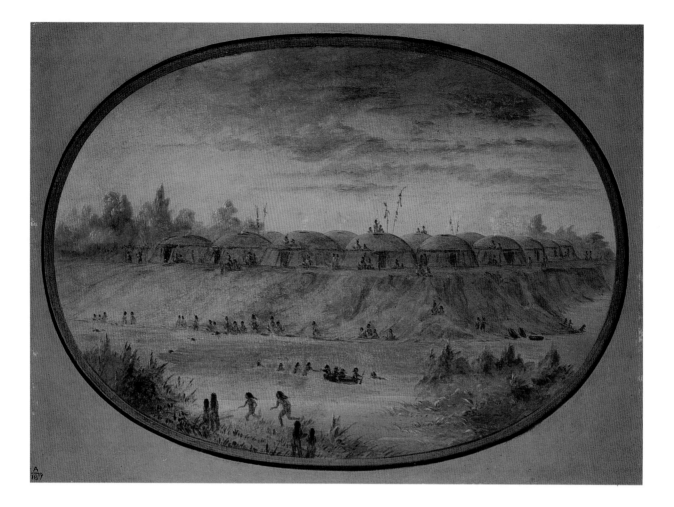

of the Principal Chiefs (*page 18*). The title of the book indicated that Indian history was to be portrayed through the lives of the individual leaders who served as representatives of their tribes. McKenney used the images of Indians he had commissioned from Lewis, Charles Bird King, and a few other artists, and he prepared biographies to accompany the pictures. However, he found he did not have the resources he needed to prepare a text, so he went into partnership with James Hall, who served as the author for much of the book. (Because of the complexity of the project, several publishers and lithographers were involved in the production of the book. To allow the printmakers to study the paintings, another artist, Henry Inman, painted copies of the original pictures.) The McKenney-Hall publication, although a financial drain on all who were associated with it, was widely distributed and placed the portraits of Indian chiefs before a larger audience than Lewis's book. The portrait style of Charles Bird King, which was more polished than Lewis's, provided a stronger base for the production of lithographs, and the result was a much

GEORGE CATLIN (1796–1872)
Minnetarree Village—
Seven Miles above the Mandans
on the Bank of the Knife River
c.1855–1870. Oil on paper, 17⅞ × 24½"
Gift of Paul Mellon
26.86

In this painting, Catlin depicted himself with his two men crossing the Knife River (in present-day North Dakota) in a canoe. By including himself, Catlin reminds the viewer that the artist was a witness to the scene he painted.

20

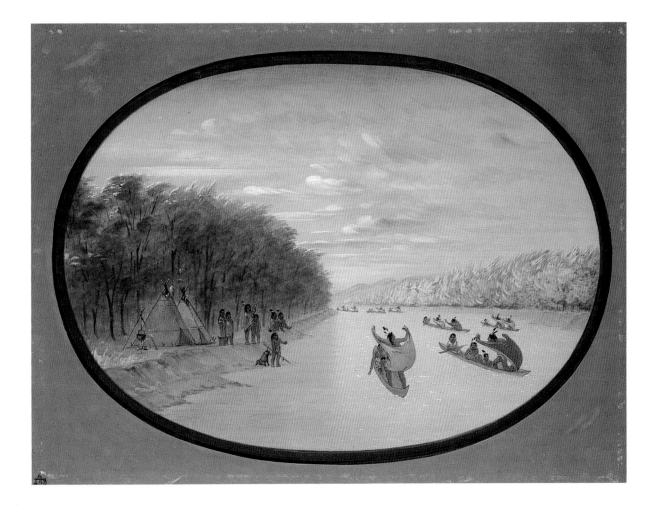

In *Letters and Notes*, Catlin recounted a scene that perhaps inspired this picture: "I was induced to make a sketch of one which I frequently witnessed, that of sailing with the aid of their blankets, which the men carry; and when the wind is fair, stand in the bow of the canoe and hold by two corners, with the other two under the foot or tied to the leg, while the women sit in the other end of the canoe, and steer it with their paddles."

more sumptuous publication. The eyewitness character of Lewis's images, although necessary for documentation, was not sufficient for commercial success.

A third, lavishly illustrated publication on Indians and their artifacts was created by the Swiss artist Karl Bodmer. Bodmer came to the United States in 1832 with the Austrian prince Maximilian of Wied-Neuwied, a natural history enthusiast who wanted an artist to document his American journey. Bodmer's watercolors were printed as hand-colored aquatints to accompany Maximilian's own narrative, which was published as *Travels in the Interior of North America*. The images are some of the most visually dramatic depictions of the American Indian ever made (*page 25*).

These three early nineteenth-century publications were the first books to present bodies of authentic—yet artistic—images of the American Indian. Because of the expenses involved in the hand-colored prints, the portfolios were still restricted to a relatively exclusive audience, but they reached more people than individual paintings could.

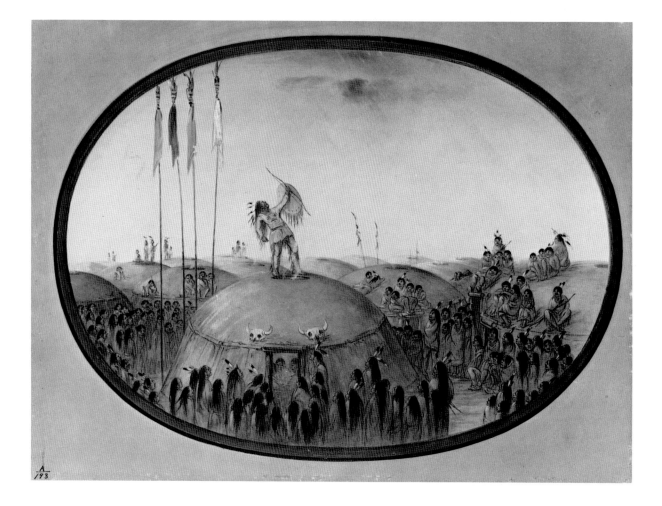

James Otto Lewis, Charles Bird King, and Karl Bodmer depicted Indians because of commissions they received. George Catlin, by contrast, decided on his own to paint the Indian people, although he clearly hoped to obtain government patronage for his work. Catlin devoted his career to building a collection of his paintings of Indians: between 1830 and 1836, he visited over fifty tribes, producing hundreds of paintings. He spent the rest of his life building and exhibiting his collection and then trying to sell it. Catlin also wrote several books, the most important of which was his first, *Letters and Notes on the Manners, Customs and Condition of the North American Indians*.

Published in 1841, *Letters and Notes* was illustrated with engravings after his paintings, and the text told of the adventurous journeys he made to study the North American Indian people in their native habitat. Because of his dramatic experiences in the West, the book established Catlin as both a heroic explorer and an authority on Indians. Whereas James Otto Lewis had apologized for the difficulties under which he

Catlin described the rainmaking ceremony in a catalogue of his paintings: "From excessive drought, the women begin to cry; their maize and vines are withering up, when the doctors order the young men to commence this ceremony of summoning the clouds and commanding it to rain, and they always succeed, for the ceremony never ceases, night or day, until rain begins to fall."

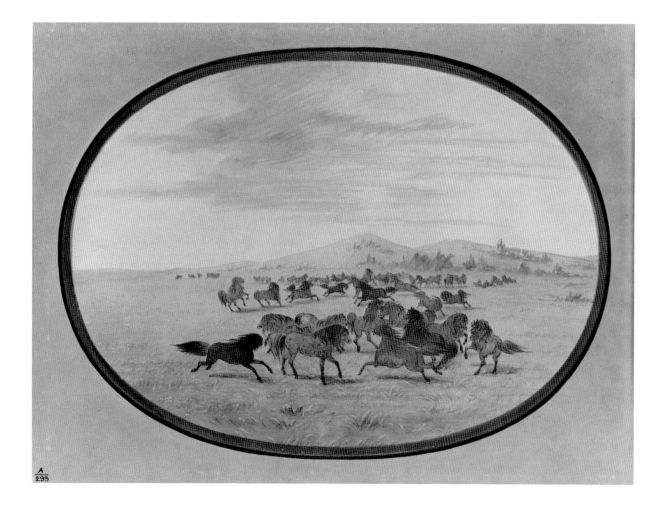

GEORGE CATLIN
Wild Horses at Play
c.1855–1870. Oil on paper, 18 × 25".
Gift of Paul Mellon
30.86

Catlin wrote in his journal: "There is no other animal on the prairies so wild and so sagacious as the horse." This painting conveys the wildness of the horses through the strong, lively outlines that define the forms of the swirling herd. The animals' wisdom might be seen in their large, searching eyes, which signified an alertness that made it difficult for Catlin to approach them.

completed his images, Catlin relayed his sagas into a popular book. "I set out alone, unaided, and unadvised," he recalled in the text to his 1848 catalogue. Although his journeys were arduous and his voluntary mission was pursued with great determination against many real odds, his statement in fact dramatizes his circumstances, for he traveled with others, was given aid by the military in reaching some locales, and received advice from eminent explorers, including General William Clark. The form Catlin chose to tell his story—letters from a traveler—emphasizes the lengths the artist had gone to in order to capture the remote subject matter for his audience. Catlin actually first published sections of what would become his book as a series of letters in the newspaper *New York Commercial Advertiser*. The fourteen letters, written between July 24, 1832, and September 30, 1837, provided material that he later included in *Letters and Notes* with minor changes. The intention behind these letters clearly was to build an audience for his paintings.

Throughout the text of *Letters and Notes*, the mystical

powers of the artist are suggested: "The operations of my brush are mysteries of the highest order to these red sons of the prairie," Catlin wrote. In another instance, he noted that the Indians "pronounced me the greatest medicine man in the world for they said I had made living beings." He told of the magic of his images—a magic that once jeopardized his own life. He had painted a portrait of Little Bear, a Hunkpapa Indian, in profile, causing Little Bear's companions to mock him as they read the painting only according to what they saw. "He

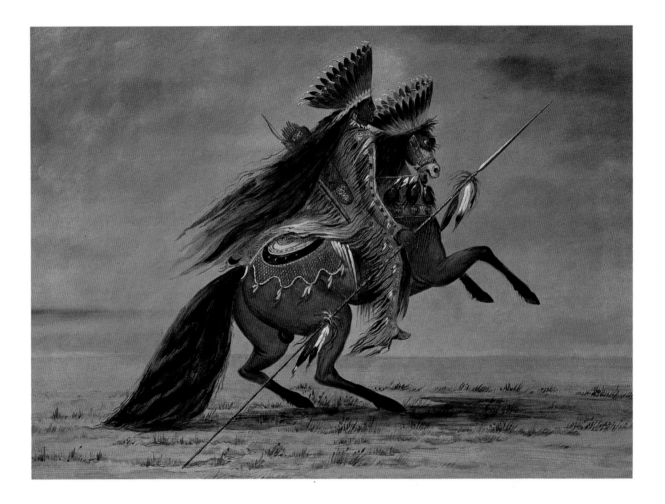

knows you are but half a man," they said. "He has painted but one half of your face." An altercation occurred, and Little Bear had half of his face shot away—the half that Catlin had not painted. The Indians decided that Catlin's medicine was too great and demanded that he die, but Catlin was able to avoid their furor. Such incidents are always annotated with a reference to "these superstitious people," and yet a continuing refrain in the book suggests that Catlin himself saw his images as magical and life-creating.

24

George Catlin assured his many readers and those who visited his Indian Gallery that of the Indians he met during his 1832 journey up the Missouri River the Crow were the most beautifully adorned. They were also known for their extraordinary feats of horsemanship. In *Crow Chief*, Catlin borrowed a pose from classical equestrian statuary to ennoble this colorful figure from the Rocky Mountains.

The impression made on Catlin by the Crow chief must have been substantial as the portrait is one of only two full-length equestrian figures out of the many hundreds of portraits in his Indian Gallery. The other instance was his portrait of the distinguished Sac and Fox chief Kee-o-kuck. The compositional associations with antique sculpture suggest that Catlin—along with many painters of his day—likened the Indian's figure to ideal classical forms.

In his publication *Travels in the Interior of North America*, Prince Maximilian of Wied-Neuweid described the young Assiniboin Indian, Pitatapiu, whom Bodmer portrayed in this work. Maximilian wrote, "His hair hung down like a lion's mane, especially over his eyes. . . . This slender young man had his painted leather shield on his back, to which a small packet, well wrapped up, his medicine or amulet in horse stealing, was fastened, and which he greatly prized."

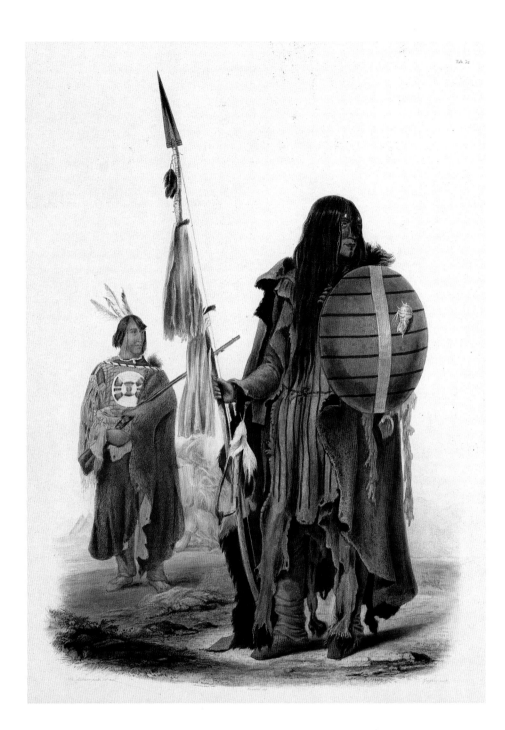

Catlin used his text to suggest that the Indian race was dying off, a theme that gave his paintings a special value. He wrote that since he had become fully convinced of the rapid decline and certain extinction of the numerous tribes of the North American Indians he had "resolved (if my life should be spared) by the aid of my brush and pen, to rescue from oblivion . . . their primitive looks and customs." Although his text emphasized the demise of the Indians, his paintings presented another message. His portraits represent bold, vivacious indi-

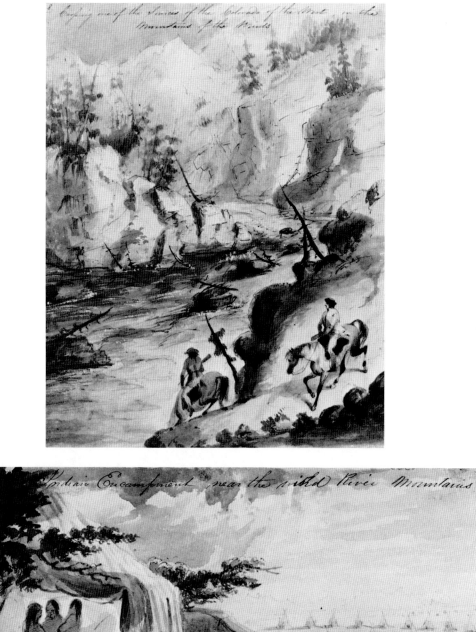

Crossing one of the Sources of the Colorado of the West, in the Mountains of the Winds

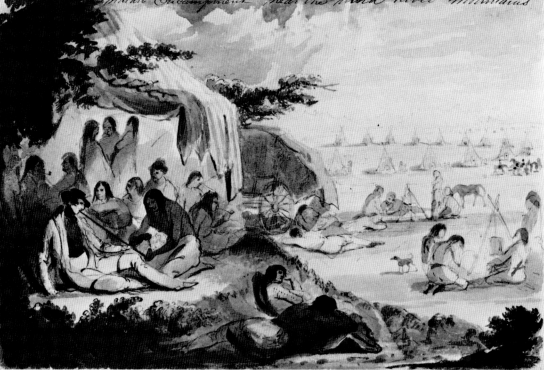

Indian Encampment near the Wind River Mountains

Miller's handling of the wash medium was delicate but confident. Curving calligraphic lines create both the sturdy, graceful horses as well as the rushing currents of the rain-swollen river. The bending river leads diagonally back into a landscape in which the pen's faint dashes describe rocky cliffs and brief smears of wash define pine trees. When using oil paint, an artist can change his mind by overpainting, but with watercolors the artist's stroke is permanent. Miller had clearly mastered this demanding medium.

Indian Encampment near the Wind River Mountains depicts the tranquil scene of Captain William Drummond Stewart's camp during his 1837 expedition. Seated in the left foreground and wearing distinguished white buckskins, Stewart holds a calumet, which an Indian is bending forward to light. Behind is Stewart's striped tent, where fur traders, trappers, and Indians have assembled for this rendezvous. Although it is a simple sketch, this work successfully conveys the mood of a lazy, warm summer's afternoon.

viduals, dressed in exotic clothing, and his vivid style of painting recreates their strong presences (*page 24*).

Letters and Notes, through its text and illustrations, also served to advertise the artist's collection of paintings and its importance. The book differs from the McKenney-Hall publication because the duplication of painted images was not its primary focus. Catlin's illustrations are unquestionably a very important part of *Letters and Notes*, but they refer the reader to the paintings themselves instead of serving as a substitute for the paintings. As line engravings, they convey the essentials of Catlin's images but do not reproduce the fluidity of his brush strokes or the power of his colors. The text never hesitates to signal the importance of Catlin's collection of paintings, which he presented as works of art.

By writing about the imminent extinction of the Indian and promoting his own image as a heroic figure and an important artist, Catlin established himself as the preeminent artist-historian of the Indian people. This should have aided him in his efforts to sell his collection of paintings to the government, yet he was never successful in this respect. Bankruptcy caused him to forfeit ownership of his Indian gallery paintings. But he recovered by painting a second series, which he called his cartoon collection, using the word "cartoon" to refer to the works as preliminary sketches. The cartoon series primarily features depictions of Indian life. While not having the strength of some of his portraits, the series includes some charming vignettes (*page 21*) as well as scenes of historical importance, including sketches of the Mandan Indians whom Catlin visited just before the tribe was nearly exterminated by smallpox (*page 22*).

The hope of securing government patronage guided the career of John Mix Stanley, who, like Catlin, created an Indian gallery composed of painted portraits and a collection of artifacts. The lack of success that Catlin had encountered did not deter Stanley, who also used the argument that the Indian race was vanishing to call attention to his work. He treated this theme in his painting *The Last of Their Race* (*page 107*), portraying the vestiges of the Indian people pushed to the edge of the sea as the sun sets on them. Stanley grouped the figures together to form a classical pyramid and used visual devices from other paintings—notably from the works of the great history painter Benjamin West—to bring an additional nobility to the painting. The painting is strengthened by his careful depiction of Indian costumes, which gives it a sense of veracity, and by his inclusion of different generations and tribes of Indian people, which broadens its message. Thus, the work has all the conventions of a "history" painting, even

though it depicts no real event. Stanley's painting is convincing, yet he never managed to convince Congress to purchase his Indian gallery, which eventually burned in a fire. *The Last of Their Race* is one of the few surviving examples of his work.

By contrast, the artist Alfred Jacob Miller did not have a strong impulse to collect Indian objects, nor was his mission to preserve the ways of the Indian people. Like Bodmer, Miller was hired by a European aristocrat, Captain William Drummond Stewart, who came to the American continent from Scotland to go hunting. Stewart hired Miller in New Orleans to provide souvenir paintings of his travels along the fur trappers' routes. The sketches that Miller made were the basis for numerous works he developed later in his career. For his patron, Miller also made a portfolio of wash sketches, using the watercolor medium to give an immediacy and freshness to his depictions (*pages 28–33*).

As he had been sponsored by Stewart to travel to the West, Miller could use the sketches from his one trip to make additional versions of his works for other patrons who wanted

ALFRED JACOB MILLER
Indians Assembled in Grand Council to Hold a "Talk"
c.1837. Pencil and ink with gray wash on paper, 8¾ × 10⅞"
Gift of The Coe Foundation
3.73

Miller's sketches of the 1837 expedition give a sense of the life of the Plains Indians he encountered. Because he did not scrutinize his subjects scientifically, Miller is not considered to be an artist-recorder in the tradition of Karl Bodmer, George Catlin, and John Mix Stanley, who strove for factual accuracy in their work. Nevertheless, his paintings give rare views of activities otherwise not recorded.

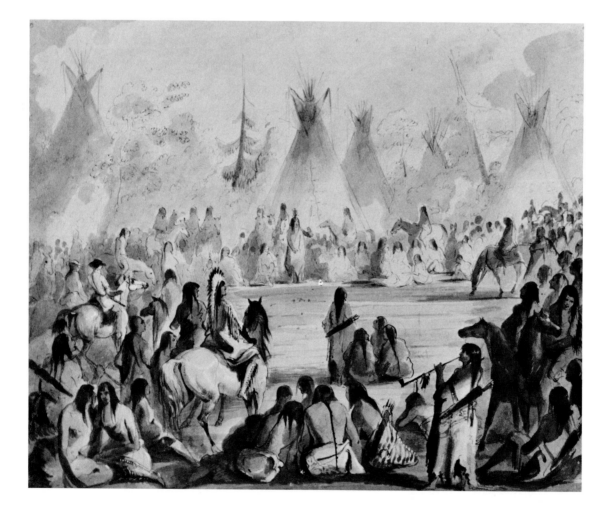

Miller is celebrated as the first and only artist to view and paint the mountain men's rendezvous. His astute comprehension of the West, technical facilities, and romantic inclinations combined to produce a body of work that is recognized today for both its historic and aesthetic merit. This scene, probably painted sometime after Miller returned from the West, shows Captain Stewart greeting a pair of trappers at the rendezvous. Stewart's caravan can be seen in the background. The exciting celebration is about to begin.

images of the frontier created by an eyewitness. *Trappers Saluting the Rocky Mountains* (*page 95*), for example, was made years after Miller's 1837 trip to those mountains. Probably painted in the 1860s, *Trappers* is based on sketches and on Miller's idealizing memory of the dramatic landscape. *Indian Elopement* (*page 34*), which has great drama and romance, was another of Miller's most popular prototypes. His *Indian Council* (*page 28*), on the other hand, exists only as a sketch. Although the composition and subject are interesting, an Indian council may not have been as appealing to Miller's patrons as some of his more romantic subjects.

Miller's one trip to the West freed him from a career that otherwise would have been devoted exclusively to portrait painting—one of the few ways an artist could find work in early nineteenth-century America. On his Western journey, Miller did paint some portraits, including one of *Louis—Rocky Mountain Trapper* (*page 33*). However, such a portrait is less a mimetic likeness than a depiction of a frontier type, the trapper. Miller turned Louis into a Western hero by drawing

upon conventional artistic devices. The trapper is presented in a contained contrapposto pose, which gives a classical elegance to his portrait, while his exotic costume, with its long fringe and elaborate headgear, emphasizes his specifically American character and adds a romantic aura to his portrayal. The subject of the trapper that Miller treated so effectively had great appeal for other artists. It served as a prototype, for example, for the unknown portraitist of the *Mountain Man* (*page 35*).

The establishment of frontier subjects as part of American iconography gave impetus to additional romantic interpretations of the individuals who encountered the wilderness. Thomas Mickell Burnham's painting of Lewis and Clark (*page 36*) is an example of this process. In the late 1830s, when Burnham left his native Boston to go to Detroit, he found work as a sign painter, an occupation that was a beginning for many artists. By 1838, he had opened a studio for portraiture and genre scenes, and it is likely that his painting of the Lewis and Clark expedition dates from that year. Since 1838 is also the date of William Clark's death, the painting may have been a memorial to the famous explorer. Burnham's picture fills a void because the important Lewis and Clark expedition had not been accompanied by an artist. His vision of

ALFRED JACOB MILLER
Indians Fording a River
Undated. Watercolor on paper, 4¾ × 6"
Gift of The Coe Foundation
33.64

Miller was always anxious to paint Indians. "For if you can weave such beautiful garlands with the simplest flowers of Nature," he once remarked, "what a subject her wild sons of the West present, intermixed with their legendary history." His patron, Captain Stewart, helped to impress upon him a noble and romantic vision of the Indian, pointing out those Indians in his paintings that had "not sufficient dignity in expression and carriage." Such dignity is seen in his two subjects in *Indians Fording a River*. In this small watercolor, the eye is immediately drawn to the central figure, who sits erect and proud, holding high her quirt and gazing out toward the viewer. In the distance is her partner and protector, who goes first into the water to check for a safe crossing.

Elk Hunting in the Rocky Mountains
c.1837. Pencil with brown and gray
washes on paper, 8 × 7"
Bequest of Joseph M. Roebling
9.80

On his trip to the Rocky Mountains for the annual fur trappers' and traders' rendezvous of 1837, Miller produced over two hundred watercolor sketches of scenes in the lives of fur traders and Indians that he encountered. In this work, two trappers, dressed in their buckskins and perched on a rocky precipice, shoot their ambushed prey. Miller, an astute observer, explained: "The man who here deliberates is lost: i.e., loses his shot—there is not much use in running the elk without stratagem is used [*sic*], either in heading them off, forcing them into the river, or waiting at some point hidden, and shooting them as they pass."

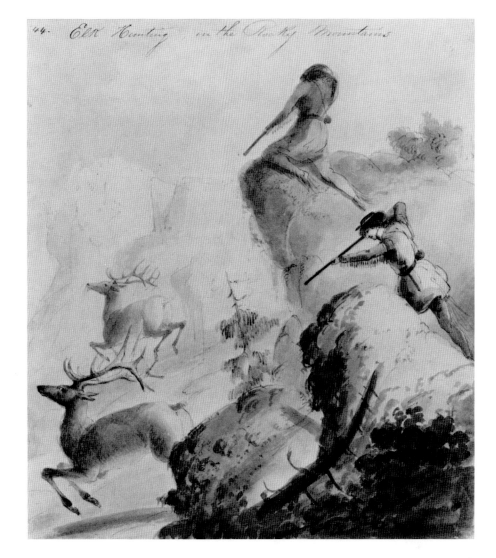

the explorers in the wilderness was an effort to translate the expedition into the mode of history painting.

As expeditions continued to explore the western territories, artists played important roles in bringing back information about the land and the wildlife and in using these subjects to develop a distinctly American art. William Jacob Hays made only one major trip to the Missouri River basin, but this was the basis for his many wildlife paintings. His painting *A Herd of Bison Crossing the Missouri River* (*page 37*) was one canvas in a three-part portrayal of the massive buffalo herds of the Plains. Hays, traveling in 1860, was impressed by the thousands of buffalo that could still be seen, but he was aware that the animals were being extensively hunted and faced potential extinction. His paintings celebrated the buffalo at a time when the buffalo, like the Indian, was considered to be in danger of vanishing from the continent. His paintings

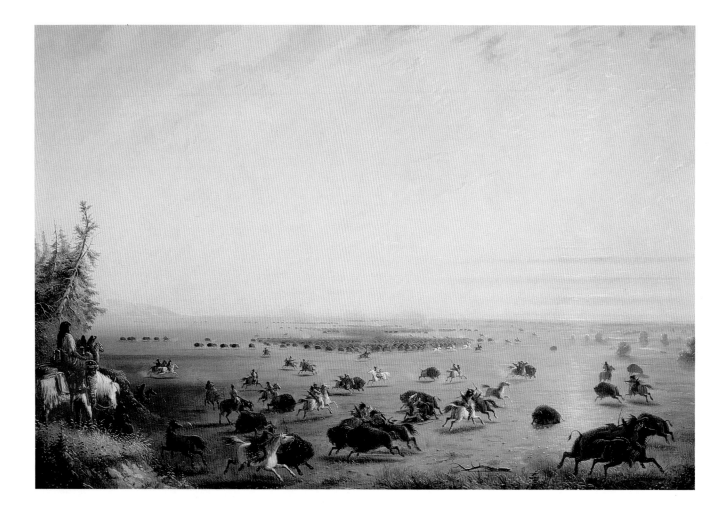

were intended to be valued for preserving what soon would be lost.

In the early nineteenth century, the American landscape had become an important component in the iconography of American art both in the East and the West. Although government expeditions had often included artists in their parties, these painters often lacked formal training and for various reasons failed to become major figures in American artistic circles. However, by the middle of the nineteenth century, the artists who traveled out West, such as Albert Bierstadt, brought trained eyes to their subjects and created works that had a dramatic impact on the perception of the frontier.

Bierstadt came to the United States from Europe at an early age, but he later returned to Europe for formal art training in Düsseldorf, Germany. To promote his career, he created a persona for himself that combined a European concept of the artist as gallant courtier with the American concept of the frontier traveler. He and his wife entertained on a lavish scale,

ALFRED JACOB MILLER
Surround of Buffalo by Indians
c.1848–1858. Oil on canvas,
30³⁄₈ × 44¹⁄₈"
Gift of William E. Weiss
2.76

Miller once described the buffalo hunt: "[The Indians] all start at once with frightful yells and commence racing around the herd, drawing their circle closer and closer, until the whole body is huddled together in confusion. Now they begin firing, and as this throws them [the buffalo] into a headlong panic and furious rage, each man selects his animal."

Rather than showing the bloody frenzy of the hunt, Miller depicts agile, athletic Indians astride graceful, prancing horses. The sky, filled with hues of pink and orange, is influenced by the work of J. M. W. Turner, whose paintings Miller admired and copied.

which helped to cultivate society patronage, and, like other artists who traveled out West, he collected objects, especially American Indian artifacts, to keep in his studio in New York. He was not, however, amassing an ethnographic record like George Catlin's. Bierstadt was interested in Indians primarily for their picturesque qualities and included them as details in his landscapes. Similarly, his collection of Western objects served to create in his studio a milieu that evoked the West for the benefit of his creative inspiration and was also perhaps for the interest of visitors to his working environment. In this way, he reinforced his social identity as a frontier artist.

ALFRED JACOB MILLER
Louis—Rocky Mountain Trapper
Undated. Watercolor on paper,
7⁷⁄₈ × 5³⁄₄"
Gift of The Coe Foundation
36.64

During the course of Miller's summer in the Rocky Mountains in 1837, he painted individual portraits of many of the trappers. Some of the trappers are known by their full names—old Bill Burrows and Antoine Clement among them—others, such as "Auguste" and "Louis," are known only by their given names. In this portrait, the trapper Louis rests over his fallen prey while loading his Hawken rifle for another shot. His proud stance imbues him with heroic qualities.

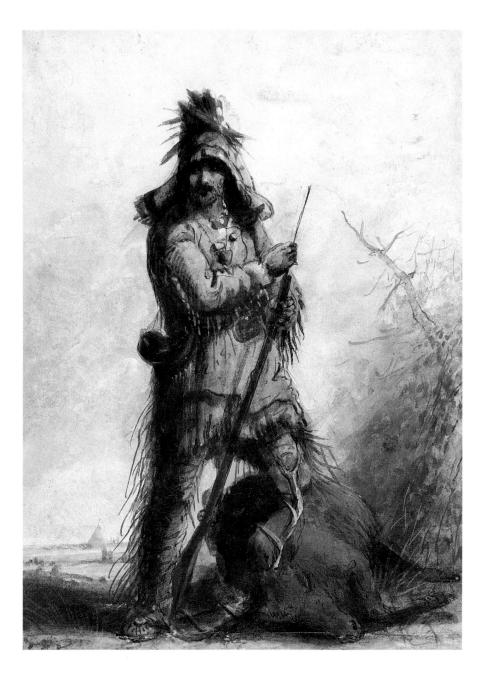

ANONYMOUS
(POSSIBLY JOHN MURDOCH)
Mountain Man
c.1853–1854. Oil on canvas,
21¼×27¼"
23.78

The mountain man became a symbol of the free and independent life in the American wilderness. In this painting, the artist also showed the frontier was a place of conflict and danger. A stamp on the reverse of the canvas identifies the painting's origin as St. Louis in the middle of the nineteenth century.

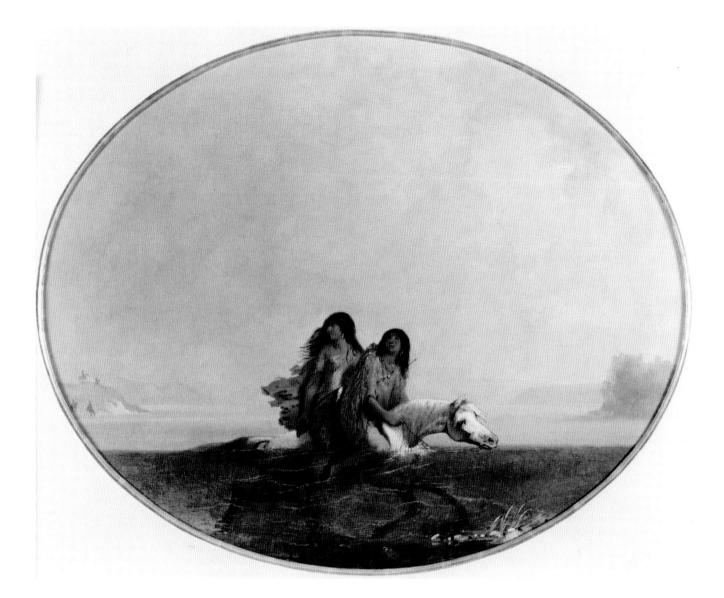

ALFRED JACOB MILLER
Indian Elopement
1852. Oil on canvas, 30¼ × 36¼"
Given in memory of Mai Rogers Coe by
her son Robert Coe.
28.64

Miller painted this theme at least
three times and must have found it par-
ticularly suitable for his romantic inter-
pretation of the West. He once
explained the scene's narrative:

Our hero here has been struck
by the dusky charms of a girl in
the camp of a different tribe
and could readily effect his pur-
pose by purchase—but his sole
possession is a horse. Will he
give that for her? Not he! By
stratagem and adroitness he
knows the prize may be gained.
In watching the opposite camp
he ascertains when the war-
riors leave for hunting, or
forays, and seizing the opportu-
nity alights from his horse at
the entrance of her lodge—
persuades or, if need be, forces
her to mount his steed, throws
himself on before, and makes
for the river at top speed—to
be sure the old men bustle,
mount their horses and pur-
sue—but they want young
blood in their veins to catch
him; he is half across the river
by the time they reach the
banks.

THOMAS MICKELL BURNHAM
(1818–1866)
The Lewis and Clark Expedition
c.1838. Oil on canvas, 36¹/₈ × 48¹/₂"
21.78

During the halcyon years before
the Civil War, American painters looked
westward for inspiration and for dis-
tinctly American themes. Painters of
genre and historical scenes explored a
variety of subjects related to the open-
ing of the West, concentrating especial-
ly on the Indian and the mountain man.
By mid-century, they also focused on
American explorers, particularly Daniel
Boone, who was regarded as an exem-
plary American hero.

It seems odd that most artists did
not expand the iconography of the he-
roic frontiersman to include the explor-
ers Lewis and Clark. Thomas Burnham,
a genre and history painter, was a rare
exception. He produced a number of
versions of a scene showing Lewis and
Clark leading their expedition west-
ward along the banks of the Missouri.

The quality of light in this paint-
ing and the abundance of foliage sug-
gest the Hudson River Valley rather
than any Western rivers that Lewis or
Clark would have explored. Neverthe-
less, the promise of America's future is
embodied in the warm, inviting light on
the distant horizon.

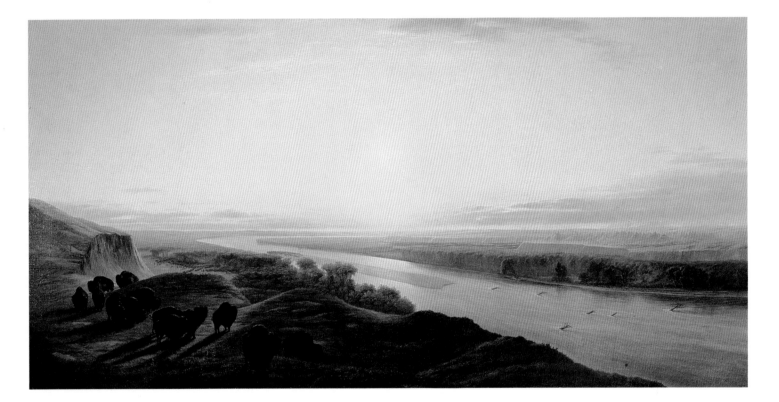

WILLIAM JACOB HAYS
(1830–1875)
A Herd of Bison Crossing the Missouri River
1863. Oil on canvas, 36 × 72"
Gertrude Vanderbilt Whitney Trust Fund
3.60

Primarily a painter of animals, Hays also succeeded in creating a splendid landscape for this work. He faced the difficult problem of conveying the immensity of the Missouri River plain. Using a high viewpoint, he made the river stretch into the far reaches of the composition.

Island Lake, Wind River Range, Wyoming (*page 39*) resulted from Bierstadt's first trip out West, on which he joined Frederick Lander's 1859 expedition that surveyed routes for western passage. On this journey, Bierstadt made on-site oil sketches and utilized the new medium of photography to collect imagery for his paintings. His studies of stereoscopic views contributed to the manipulation of perspectives in his landscapes. The bold rock formations in the foreground of *Island Lake*, for example, contrast dramatically with the silvery lake and the glowing ranges in the distance. In this way, he combined the marvelous features of the West with his own elegance and flourishes.

Bierstadt painted his view of *Yellowstone Falls* (*page 6*) after a trip to that national park in 1881. There, in addition to the sketches he made while traveling, he also collected memorabilia, including a large buffalo robe, to enhance the Western effects in his studio. He loaned several Yellowstone paintings to President Chester Arthur for the White House, trying to convince the government to purchase the works. It seems typical of Bierstadt's social aspirations that he would choose the stately home of the president as the proper location for his paintings.

Albert Bierstadt's grand tour-de-force was *The Last of the Buffalo*, in which he depicted the disappearance of the buffalo herds and perhaps by implication the Indians who depended on them. A charter member of the Boone and Crockett Club, Bierstadt and his fellow members were big-game hunters as well as conservationists. Although Bierstadt conceived this painting as his masterpiece, it became a disappointment for the artist. A version of the subject was rejected by the American jury of the Paris World's Fair, and he did not receive the acclaim he had hoped for.

In the latter half of the nineteenth century, other established artists were venturing into the field of Western landscape painting, most notably Thomas Moran. Moran became identified with the subject of Yellowstone. He had accompanied Ferdinand Hayden's government-sponsored expedition to Yellowstone in 1871 and gained fame for painting the wonders of what would become the world's first national park. Indeed, Moran's sketches of the first journey were shown by Hayden to congressmen to convince them to set aside Yellowstone as a national park. (Their plan was accomplished in 1872.) The grandeur of the Yellowstone scenery and the vivid colors of the geological formations provided Moran with the dramatic forms and hues that became the signature of his art. Moreover, the distinctive monogram the artist used to sign many of his works, prominently displayed in the series of

In 1859, Bierstadt accompanied an expedition led by Colonel Frederick Lander to the Wind River Mountains. Making oil studies and taking stereographic photographs, Bierstadt brought back to New York his first body of Western imagery. *Island Lake* features the recessive planes, meticulous brushwork, and highly polished surface texture characteristic of Bierstadt's work at this time.

chromolithographs based on his watercolors (*page 86*) emphasized his own identification with the landscape. The intersection of the T with the M forms a Y, making his middle initial stand for Yellowstone.

Moran's painting *Golden Gate* (*page 43*), completed after his second and final journey to Yellowstone in 1892, exemplifies the successful match between his visual approach and the subject matter. In this work, Moran not only depicted the natural wonders of the site, but he also documented the efforts that went into making the park. The painting represents the Golden Gate canyon, located approximately four miles from Mammoth Hot Springs in the northwest corner of the park. The cliff walls are covered with yellow lichen, which inspired the name for the pass. This natural coloration is reinforced by the warm, glowing palette of oil paints Moran used for the entire scene. The artist also carefully represented the effect of man's appearance in the wilderness: the road built along the canyon walls was a considerable engineering feat. Yet, the wagon, the horseback riders, and even the trestle-

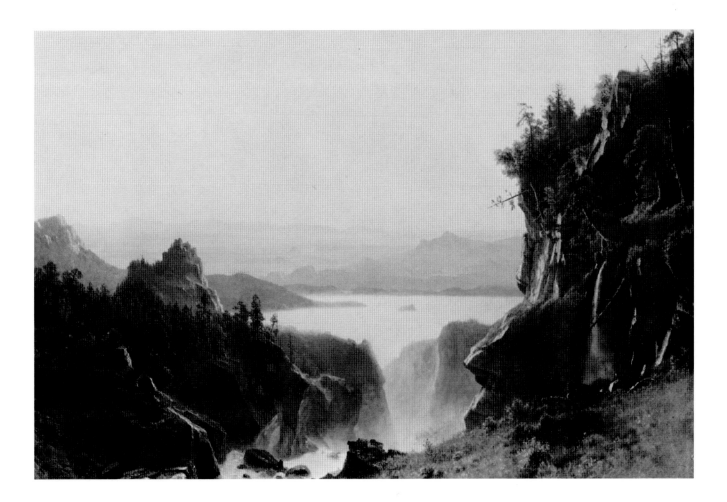

ALBERT BIERSTADT
Last of the Buffalo *(sketch)*
c.1888. Oil on board, 14¾ × 19″
Gertrude Vanderbilt Whitney Trust Fund
1.60

This small sketch served as the study for the principal figures in Bierstadt's *Last of the Buffalo* (*below*). The study's loose brushwork infuses additional excitement into the drama of the confrontation.

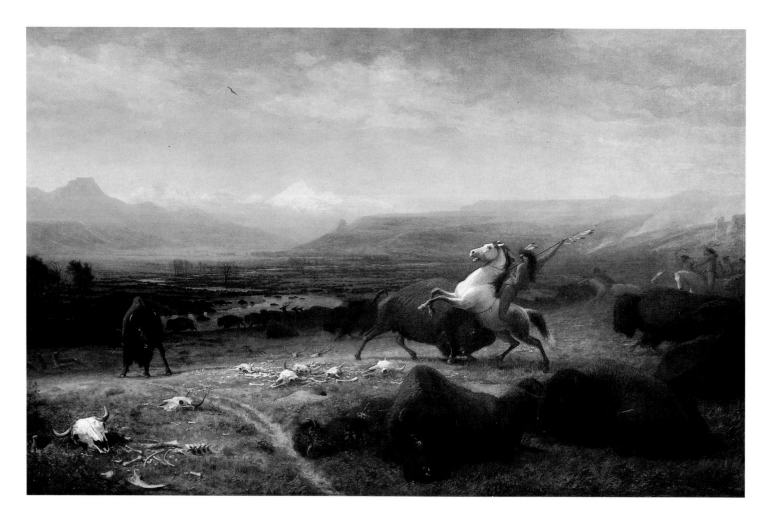

supported road are unobtrusive elements in Moran's composition, all completely dwarfed by the large, naturally formed pillar at the entrance to the pass. The human presence has not diminished the glory of nature.

Moran himself rearranged features of the pass to make this composition. Five pencil sketches of the pass that Moran made during the 1892 journey, which exist in the collection of the National Museum of American Art, reveal that he exaggerated the scale of the cliffs and ravine, thus heightening the impact of the view. In the painting, Moran leads the eye back to the waterfall, a vista which is not possible in the pass. Although no Moran watercolors of this scene have been located, the photographs of William Henry Jackson, who joined him on the 1892 journey, serve as useful reference points for many of Moran's paintings. Moran's identification with his subject of Yellowstone quickly established him as the visual authority on the subject. This imprimatur, coupled with his attractive style of painting, made his paintings convincing images. And even when he manipulated the elements of a land-

ALBERT BIERSTADT
Buffalo Head
c.1879. Oil on paper (mounted on board), 12¹/₄ × 15¹/₄"
Gift of Carman H. Messmore
1.62

Bierstadt painted this head of a buffalo probably ten years before painting his major work about the disappearance of the animal. Yet the liveliness of the animal, conveyed in the sensitively painted eye, is also captured in the later painting (*page 40*).

opposite:
ALBERT BIERSTADT
Last of the Buffalo
c.1888. Oil on canvas, 60¹/₄ × 96¹/₂"
Gertrude Vanderbilt Whitney Trust Fund
2.60

By including dying buffalo and bleached skulls in the painting's foreground, Bierstadt represented the theme of wildlife vanishing from the wilderness. He made the shapes of the distant mountains repeat the shapes of the animals to underline the interdependent relationships of nature.

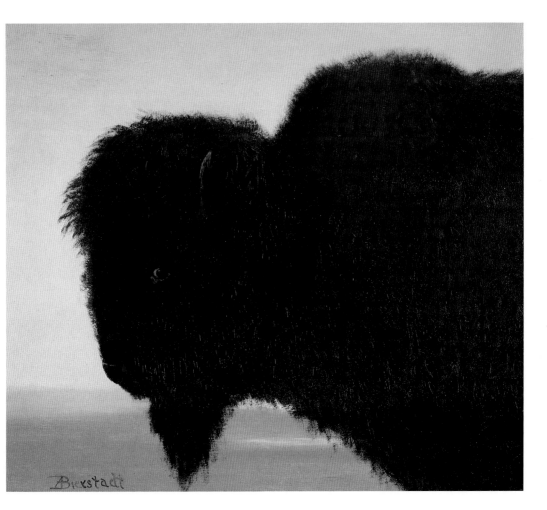

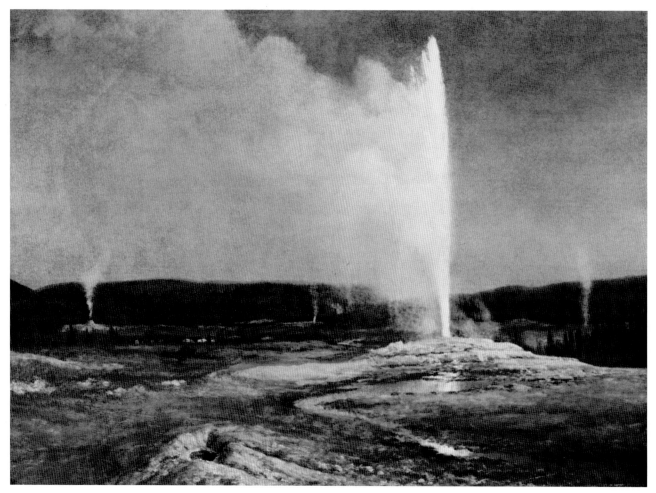

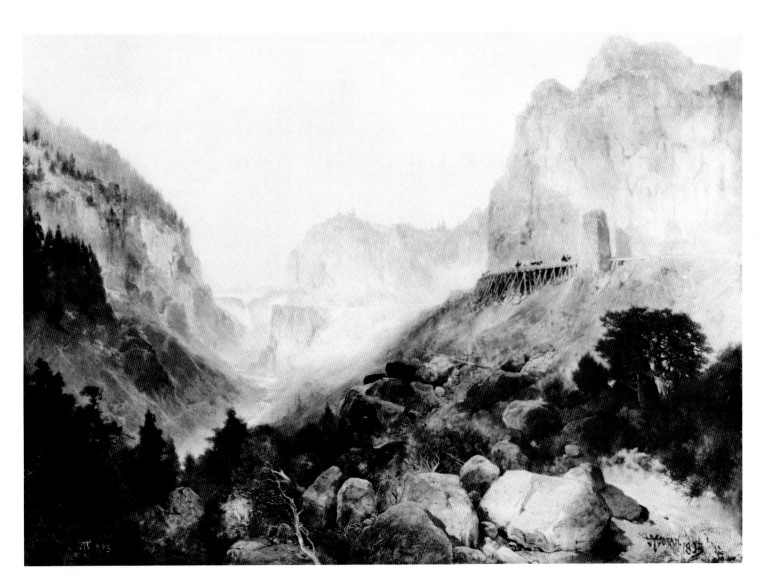

opposite top:
WORTHINGTON WHITTREDGE
(1820–1910)
Longs Peak from Denver
1866. Oil on canvas, 12⅞ × 23⅝"
Gift of William B. Ruger
8.84

Worthington Whittredge, a native of Ohio, is usually associated with the Hudson River School artists, but he made several important trips to the West. With Major General John Pope he traveled to New Mexico and Colorado, where this sketch was made on June 27, 1866. Inspired by the Plains rather than the mountains, Whittredge painted idyllic, verdant scenes. He made two additional trips westward, including one in 1870 when he traveled with fellow artists John Kensett and Sanford Gifford.

opposite bottom:
ALBERT BIERSTADT
Geysers in Yellowstone
c.1881. Oil on canvas, 26¼ × 36"
Gift of Townsend B. Martin
4.77

The spray of the many geysers in the newly created Yellowstone National Park inspired the use of soft forms and colors in this painting.

above:
THOMAS MORAN (1837–1926)
The Golden Gate
1893. Oil on canvas, 36¼ × 50¼"
4.75

Moran's representation combines many of the wonders that could be found in the Yellowstone region. The extraordinary hues of the geological formations and the vegetation were the perfect inspiration for the artist, who was influenced both by J. M. W. Turner and the critic John Ruskin.

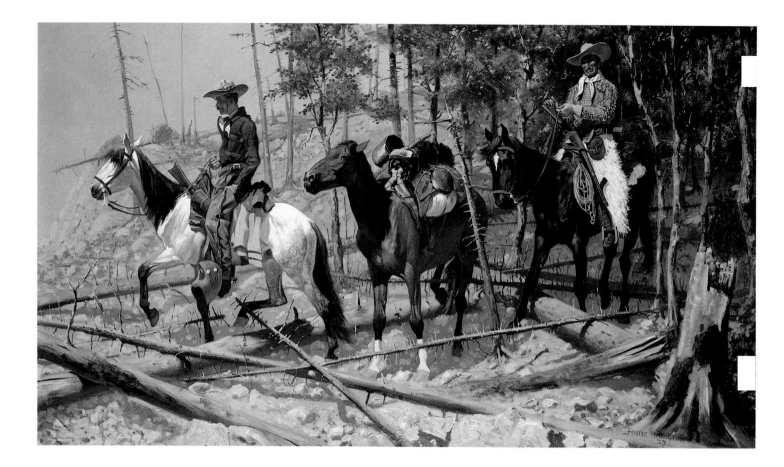

scape, Moran was truthful to the sense of the place. The view seen in *Golden Gate* may not be visible from any one point, but it is a summation of experiences.

Moran exhibited *Golden Gate* at the 1894 spring exhibition of the National Academy of Design. Frederic Remington, who admired the vista, said of the painting, "Mr. Thomas Moran made a famous stagger at this passing in his painting, and great as is the painting, when I contemplated the pass itself, I marvelled at the courage of the man who dared the deed."

Remington's praise for the artist's courage in making the painting typifies his own feelings about the West. For Remington, the West was a place where courage was required, and he believed that quality should be expressed emphatically in the art of the West. Remington first identified himself with the West as a reporter and illustrator for popular magazines. It was a way to support himself as an artist and to portray the exciting events of the West that were so attractive to him. With his paintings of cowboys, military leaders, and warring Indians, he provided images for the Eastern and European audiences waiting to devour tales of the West.

FREDERIC REMINGTON
(1861–1909)
Prospecting for Cattle Range
1889. Oil on canvas, 29¼ × 50¼"
Gift of Cornelius Vanderbilt Whitney
85.60

Particularly in his early career as a painter, Remington took advantage of a number of opportunities to paint portraits of Westerners at work. In 1889, he accepted a commission to show Milton E. Milner and an associate, Judge Kennon, searching for new cattle ranges in Montana Territory. The commission provided a welcome opportunity for Remington to provide some pictorial insights into the cattle business, to paint horses and cowboys at work, and to produce a double portrait.

44

In the fall of 1890, Remington made his yearly sojourn to the West, this time to Montana and the Big Horn Mountains, to gather material and inspiration for his art. The graphic realism and action of *The Buffalo Hunt* exemplifies his early style. Remington turned a typical event in the life of the Indian into a moment of tragedy and drama, reminding the viewer of the constant dangers of life in the West.

Like most artworks depicting the American West, the value of Remington's illustrations was often thought to be in their eyewitness authenticity. Yet, instead of supplying others' assurances as certificates of authenticity, as James Otto Lewis had, Remington emphasized his own participation in the life in the West. He presented himself as an outdoorsman, even though the time he actually spent in the West was limited. Except for a brief period in Kansas, Remington remained an Easterner all his life, using his Western journeys only to gather material. His paintings were made to be convincing, however, through an accumulation of details. *The Prospectors*, or *Prospecting for Cattle Range* (*page 44*), is as tightly packed with details as the load on the pack horse depicted in the painting. The grove of trees that cuts off the painting's background pushes all the contents of the picture toward the picture plane, and the fallen trees on the ground form a mesh that traps the three horses and keeps them enclosed in the

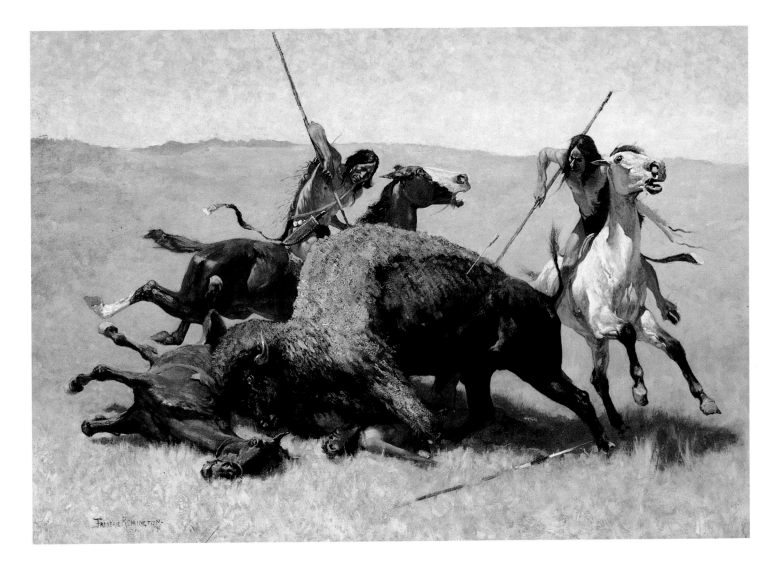

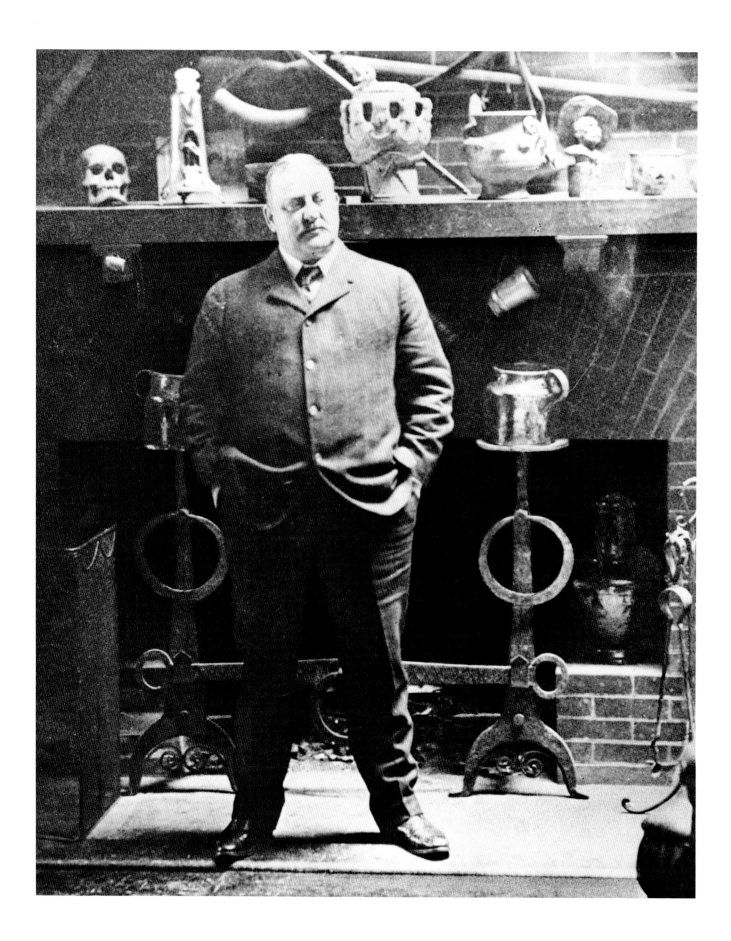

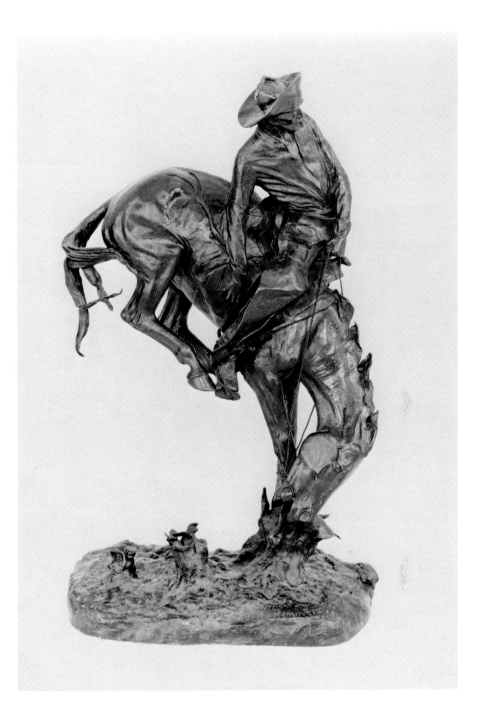

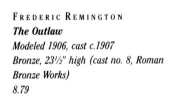

FREDERIC REMINGTON
The Outlaw
Modeled 1906, cast c.1907
Bronze, 23½" high (cast no. 8, Roman
Bronze Works)
8.79

Remington explored a variety of sculptural motifs in his depictions of the cowboy and the untamed horse. *The Outlaw*, *The Bronco Buster*, and *The Wicked Pony* confirm the important role that such scenes played in his vision of the West. The cowboy, in his efforts to conquer the wild horse, was a symbol of civilization's general exertions to control the Western wilderness.

opposite:

Frederic Remington in his New Rochelle, New York, studio in 1905. Remington had this studio built as an addition to his residence. He envisioned the massive fireplace as the focal point for the room. A model for his small sculpture *The Sergeant* sits on the mantle.

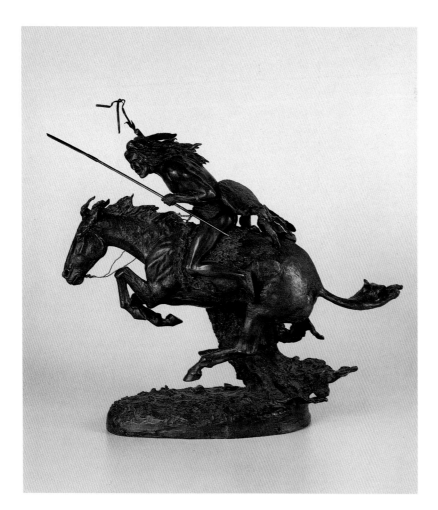

shallow space. Even when he simplified the backgrounds of his paintings, as in *The Buffalo Hunt* (*page 45*), Remington retained compositional density by compacting the two Indian hunters with their horses, the buffalo, and the fallen rider and horse into one mass.

The details necessary for completing his paintings were often supplied by the objects Remington collected. His studio was crammed with artifacts that he gathered on his sojourns out West (*page 12*). Indeed, Remington's affinity for objects may have contributed to his interest in experimenting with sculpture, as he had no training in the medium earlier in his life. His first sculpture, *The Bronco Buster* (*page 50*), reveals his strong sense of plastic form, which is reinforced by his considerable attention to details. The *Bronco Buster* also exemplifies Remington's interest in action and drama: the cowboy's tenacity, skill, and courage are tested by the power of the bucking horse.

Remington seemed to delight in the tactile quality of sculpture, and he often tested the medium's characteristics.

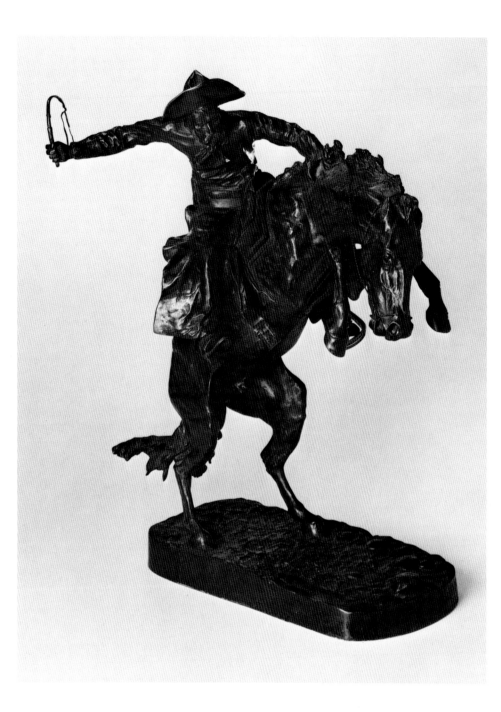

FREDERIC REMINGTON
The Bronco Buster
1895. Bronze, 23⅜" high (cast no. 21,
Roman Bronze Works)
Gift of G. J. Guthrie Nicholson III in
memory of his grandfather G. J. G.
Nicholson
7.74

The Bronco Buster was Remington's first experiment in bronze. The piece was so vital and energetic and so untraditional in its approach that it won him immediate recognition as a sculptor and helped establish him as one of the leading American artists of the day.

Remington was enthusiastic about the artistic potential for his sculpture and wrote to Owen Wister in 1895: "All other forms of art are trivialities—mud—or its sequence 'bronze' is a thing to think of when you are doing it—and afterwards too. It don't decay. The moth don't break through & steal—the rust & the idiot cannot harm it."

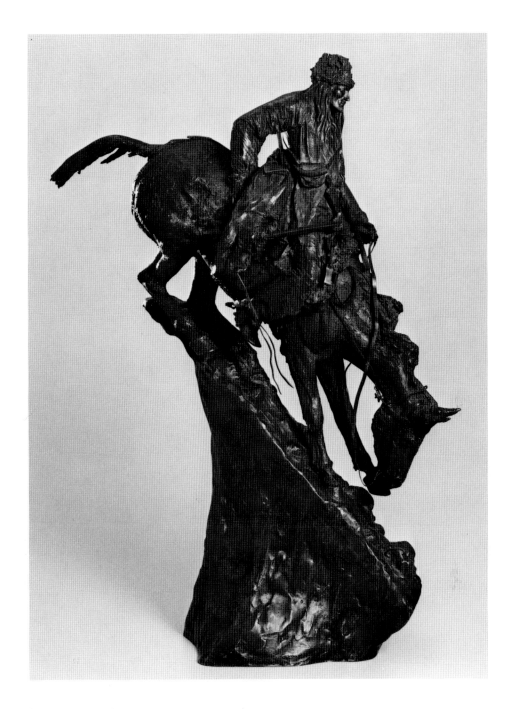

FREDERIC REMINGTON
The Mountain Man
*Modeled 1903. Bronze, 28" high (cast
no. 14, Roman Bronze Works)*
1.81

One of Remington's favorite historical subjects was the mountain man. He relished depicting the Iroquois and French trappers who hunted in the Rocky Mountains in the first half of the nineteenth century. In this bronze he has portrayed just such a figure descending a steep mountain slope with the confidence and surefootedness that allowed the trappers to open America's most forbidden reaches.

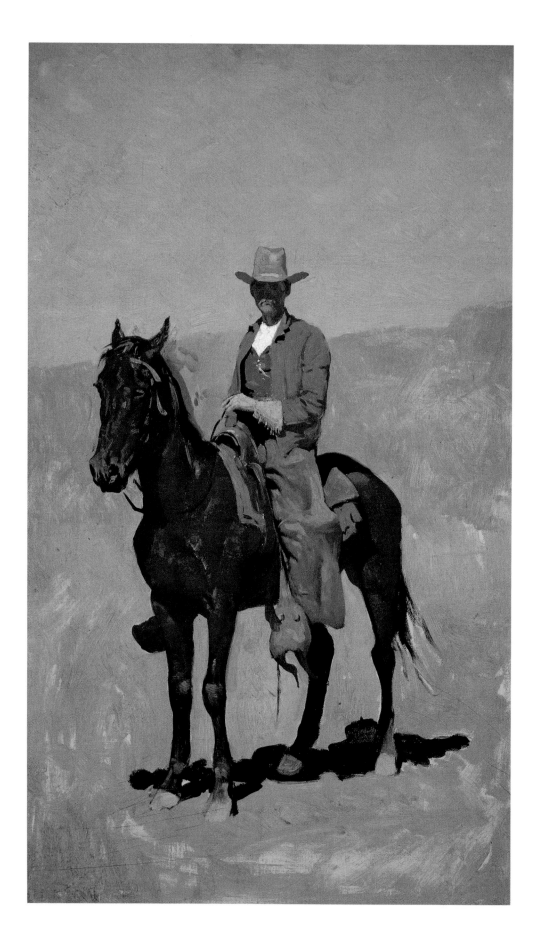

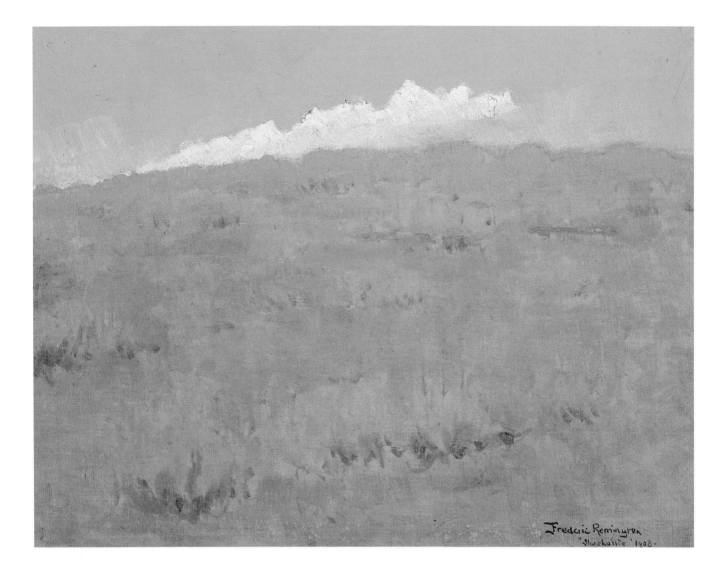

opposite:

FREDERIC REMINGTON
Mounted Cowboy in Chaps with
Bay Horse
c.1908. Oil on canvas, 30¼ × 18⅛″
Gift of The Coe Foundation
65.67

In order to produce works that possessed energy and thematic credibility, Remington traveled extensively throughout his career. Since his studios were in New York and Connecticut, he had to journey West to gather material about the frontier. He made numerous studies, including this typical oil sketch of a mounted cowboy, which was probably painted in Wyoming in 1908 during a visit to one of Buffalo Bill's ranches.

above:

FREDERIC REMINGTON
Shoshonie
1908. Oil on canvas, 12 × 16″
Gift of the Coe Foundation
38.67

In September 1908, Remington went to the West for the last time. His destination was Cody, Wyoming, where he stayed with William F. Cody at his ranch and painted. Inspired at this point in his career by the Impressionists and his contemporaries who were *plein air* artists, Remington worked out of doors, trying to paint the light and colors of the Western landscape.

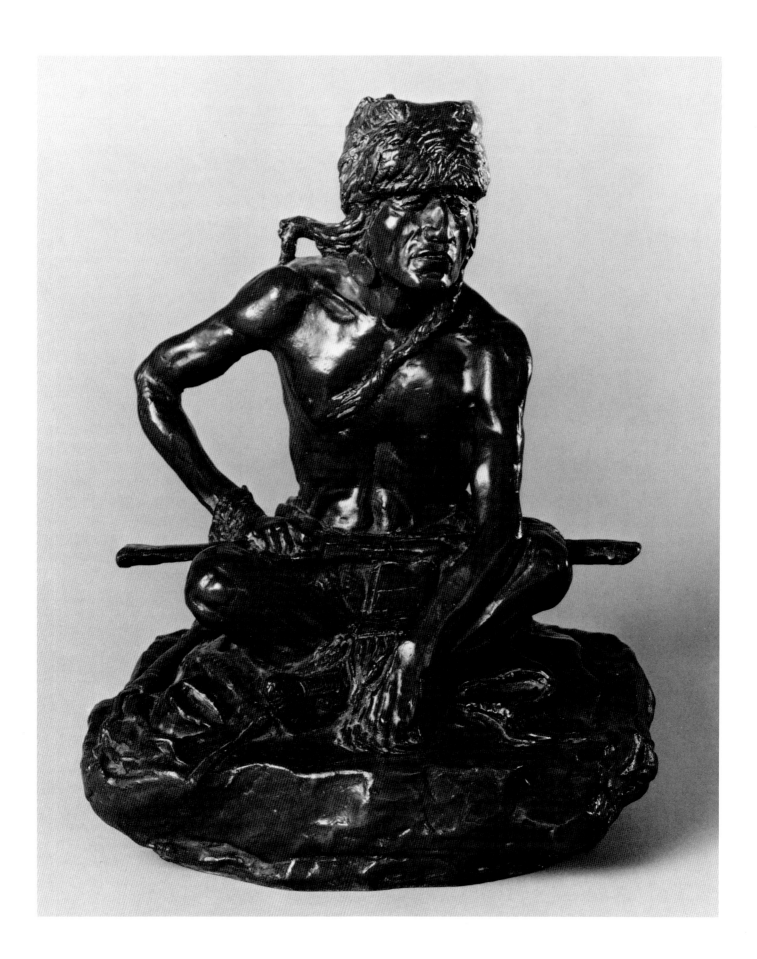

In *The Bronco Buster*, for example, the weightiness of the horse and rider are supported only by the horse's two legs. Yet, Remington created an aesthetic balance with the asymmetrical curving form. Figurative action is also an important element in his sculptures. The fierce face and the furious movements of *The Cheyenne* (*page 48*) reinforced the image of the Indian as a wild savage and an enemy. Remington's representation of action in the solid, static medium of sculpture gives his three-dimensional works a strong narrative element. In *The Mountain Man* (*page 51*), the steep incline and the precariousness of the horse and rider suggest that this is one moment in an intense drama. In his group sculpture *Coming Through the Rye* (*page 49*), the artist attempts to defy gravity by his treacherously balanced representation of galloping horses.

Once he had established his identity as an authority on the West, Remington sought recognition as a fine artist. He maintained an allegiance to his frontier subject matter, but he simplified his style, omitting many of the details that characterized his earlier work. *Radisson and Groseilliers* (*page 56*), for example, is composed of broad expanses of flat color. *Shoshonie* (*page 53*), another late work, is a landscape reduced to an abstract plane of freely applied colors.

Charles Marion Russell decided to become an artist after he had fulfilled a youthful ambition to live in the West. He went to Montana from his native St. Louis to work on a ranch, and he found life there congenial. Although he quit working as a cowboy to devote himself full-time to painting, he maintained the personality of the cowboy: he was proud, independent, knowledgeable about nature, and had a self-deprecating sense of humor. He naturally identified himself with the West. His *Self-Portrait* (*page 58*) gives a sense of how he presented himself. Standing squarely in his cowboy boots with his hat tipped on his forehead and adorned with a colorful sash—Western in origin, yet flamboyant and eccentric—he combined the roles of cowboy and artist. The illustrated letters he sent to friends reinforce his identity as an untutored, rough-hewn character (*page 58*).

Russell built up a clientele for his work in Montana first, then found he could sell his works as magazine illustrations. His wife, Nancy, managed the sale of his art, allowing him to maintain his homespun persona while she engineered his successful professional rise to national prominence. In the quiet neighborhood of Great Falls, he built a log cabin as a studio where he kept the artifacts he used for specific details in his paintings.

When Law Dulls the Edge of Chance (*page 60*), while

CHARLES M. RUSSELL
Watcher of the Plains
c.1902. Bronze, 10¾" high
Gift of William E. Weiss
3.85

An early Russell bronze, *Watcher of the Plains* expresses the sculptor's admiration for the dignity of the Indian. The plaster model for this piece is one of many models by Russell in the collection of the Buffalo Bill Historical Center.

FREDERIC REMINGTON
Radisson and Groseilliers
1905. Oil on canvas, 17 × 29¾"
Gift of Mrs. Karl Frank
14.86

Throughout his career, Remington was heralded as America's most popular illustrator of Western subjects. In 1903 he signed an exclusive contract with *Collier's* magazine to produce works in color on various historic themes related to the American frontier. As part of that commission, he initiated a series of eleven paintings for *Collier's* in 1905 entitled The Great Explorers.

The most remarkable painting in the series is *Radisson and Groseilliers*, which celebrates the French explora-

tion of the Great Lakes and the St. Lawrence River. Remington was familiar with that part of the country as he had been born in upstate New York and often visited the region as an adult.

The open brushwork and broadly painted forms, combined with the agreeable tonal harmonies, show that Remington was as much interested in the quality of paint as the subject at hand. The paintings of The Great Explorers series were experiments for Remington. Most of them, in fact, did not turn out to his satisfaction, and he destroyed all but two. *Radisson and Groseilliers* is, however, the only picture from the original set still known to exist.

opposite:
HENRY FARNY (1847–1916)
Days of Long Ago
1903. Oil on board, 37½ × 23¾"
6.75

The high horizon and the leafy, sheltering trees form an intimate setting for Farny's family group within the vastness of the frontier landscape. The picture's title wistfully places the scene in some distant, unspecified time. Farny's vision of Indian life is one of undisturbed tranquillity.

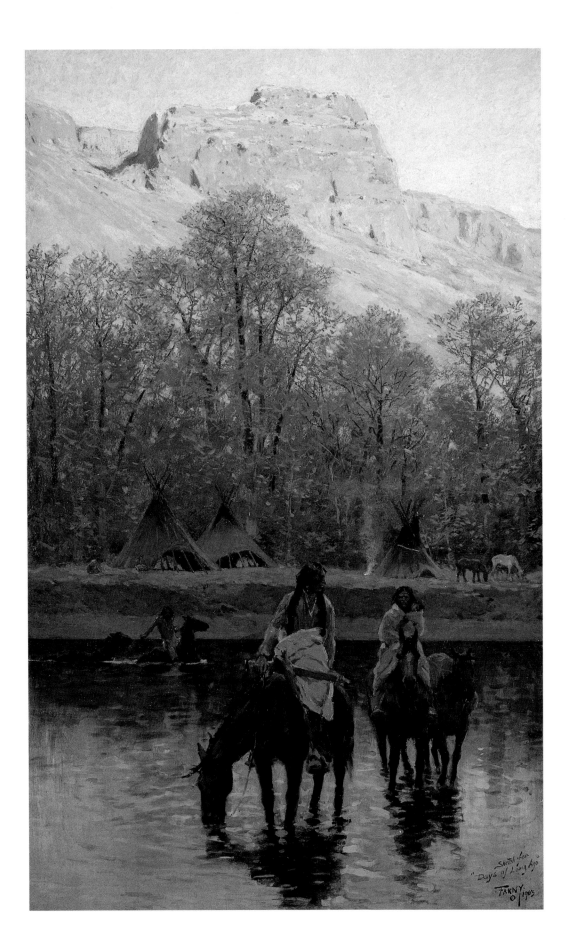

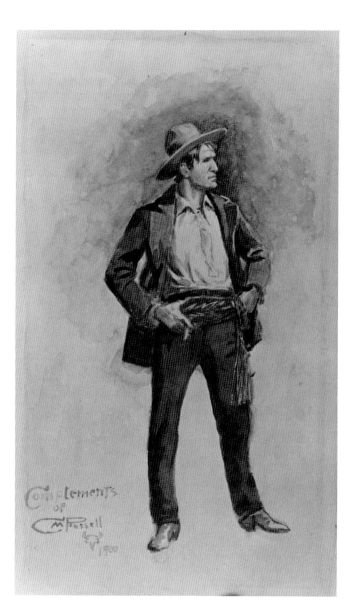

CHARLES M. RUSSELL
Self-Portrait
1900. Watercolor on paper, 12⁵/₈ × 7¹/₈"
Gift of the Charles Ulrich and Josephine
Bay Foundation
98.60

With his feet firmly planted and
his hat tipped back, Russell portrayed
himself as a stalwart, yet open person:
"I am old-fashioned and peculiar in my
dress. I am eccentric (that is a polite
way of saying that you're crazy). I be-
lieve in luck and have had lots of it. . . .
Any man that can make a living doing
what he likes is lucky, and I'm that."

June 5 1918

Friend Tex I got your card
asking how my old hoss is hes standing in
my coral right now but neather him nor
his owner are aneything like boogy old Dad time
aint hung no improvementmunts on us
judging from your card your still in the big camp
prooving to them Cliff dwelers that a ropl will
hold things with out clothes pins
If you ever cut Ed Porines range climb to
that Owls nest of his and kinder jog his

memory that he owes me som writing
tell him I got the tapadaroes and macarthey
and thank him for me

several months ago I got a card from you
saying you was a Dad of a son your
got nothing on us but ours wasent waring
our Iron but his brands vented so he's ours
all right now and we shure love him hes a yearling
past now and it keeps us both riding heard
on him

with best whishes to your best half
your self and son from the
Russell family
your friend
C M Russell

58

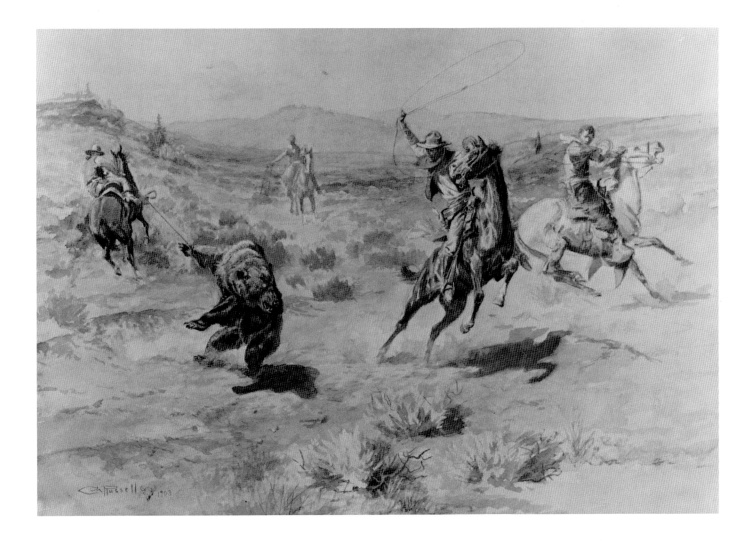

opposite right:
CHARLES M. RUSSELL
Friend Tex
1918. Watercolor and ink on paper,
14¹/₂ × 7⁵/₈"
Gift of William E. Weiss
76.60

Artists' letters often provide documentary evidence for historians, but Charles Russell's letters are a special art form that unite image and word. Usually lighthearted, the letters present Russell as a homespun philosopher. The letter to "Friend Tex" was written to Tex McLeod, a roper in Buffalo Bill's Wild West. It contains a touching passage about Russell's adopted son.

above:
CHARLES M. RUSSELL
Roping a Grizzly
1903. Watercolor on paper, 19¹/₂ × 28¹/₂"
Gift of William E. Weiss
19.73

In 1903 Nancy Russell persuaded her husband to go to New York City, the art capital of the country. *Roping a Grizzly* was one of the paintings they took to exhibit and sell. A New York newspaper headlined an article about Russell, "Smart Set Lionizing Cowboy Artist," but the Russells did not meet with great success in sales on their trip. Later, however, this painting belonged to President William Howard Taft and hung in the White House.

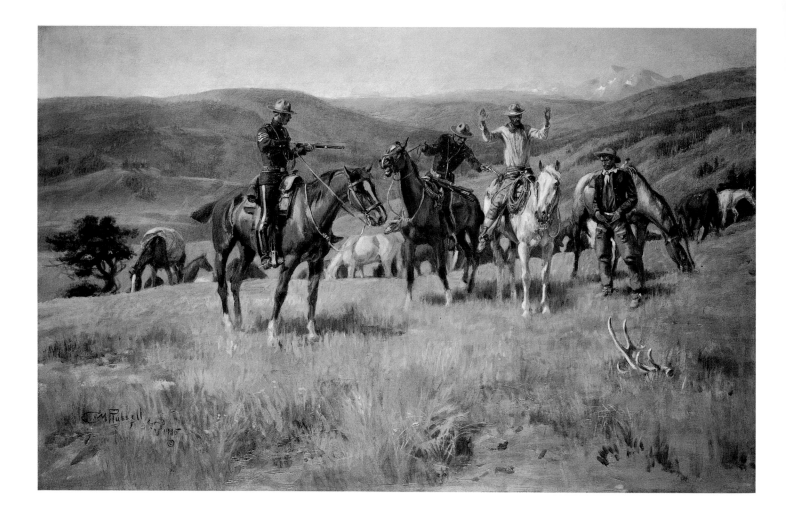

CHARLES M. RUSSELL
When Law Dulls the Edge of Chance
1915. Oil on canvas, 29¹/₂ × 47¹/₂"
Gift of William E. Weiss
28.78

The Royal Canadian Mounted Police held a special place in Russell's heart. Their colorful exploits and heroic deeds made them a likely subject for him to be drawn to. Around 1915 he concentrated on painting them. So effectively did he capture their adventurous life-style that the residents of High River in Alberta purchased this painting and gave it as a gift to the Prince of Wales in 1919.

CHARLES M. RUSSELL
The Buffalo Herd
Undated. Oil on board, 17¾ × 23¾″
Gift of William E. Weiss
21.80

For Russell, the buffalo's story assumed mythic proportions. He used an outline drawing of a buffalo skull as part of his signature, identifying himself with the tragic fate of the animal that once dominated the American landscape. His paintings of buffalo herds stopping to drink from the river portray the unity of wildlife and land in the West.

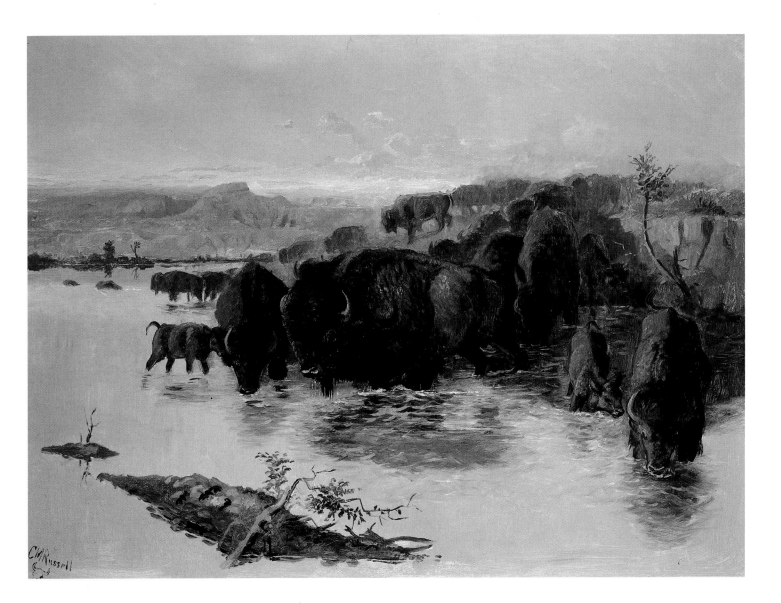

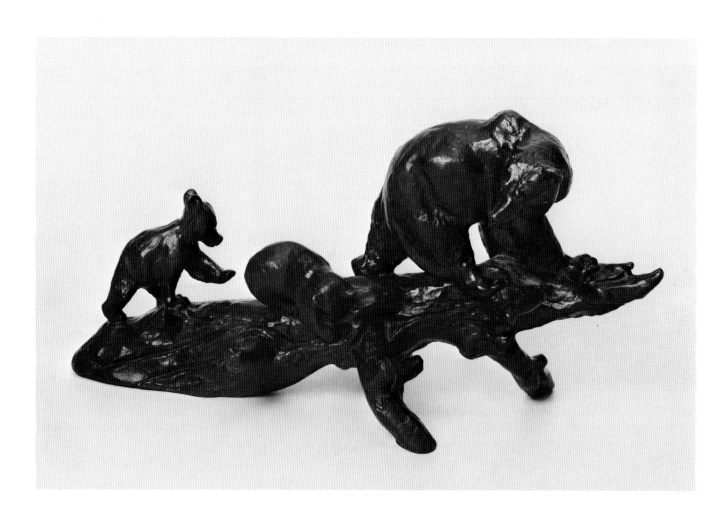

above:
CHARLES M. RUSSELL
Mountain Mother
1924. Bronze, 6¾" high
Gift of William E. Weiss
16.81

Russell's wildlife sculpture retains the impression of the artist's original modeling. The smoothly rounded forms seem to retain the effects of clay shaped in the ball of a hand. Small in scale, his bronzes have an intimate and sometimes playful feeling.

opposite:
CHARLES M. RUSSELL
The Weaver
1911. Bronze, 14½" high (cast by Roman Bronze Works)
Gift of William E. Weiss
9.81

In this piece Russell worked dynamically with the full implications of the sculpture's three dimensions. Many of his sculptures are oriented pictorially, and although they are modeled in the round they can be viewed in one plane. However, the horse and rider in this sculpture twist and turn, occupying the space fully and giving the viewer multiple vantage points.

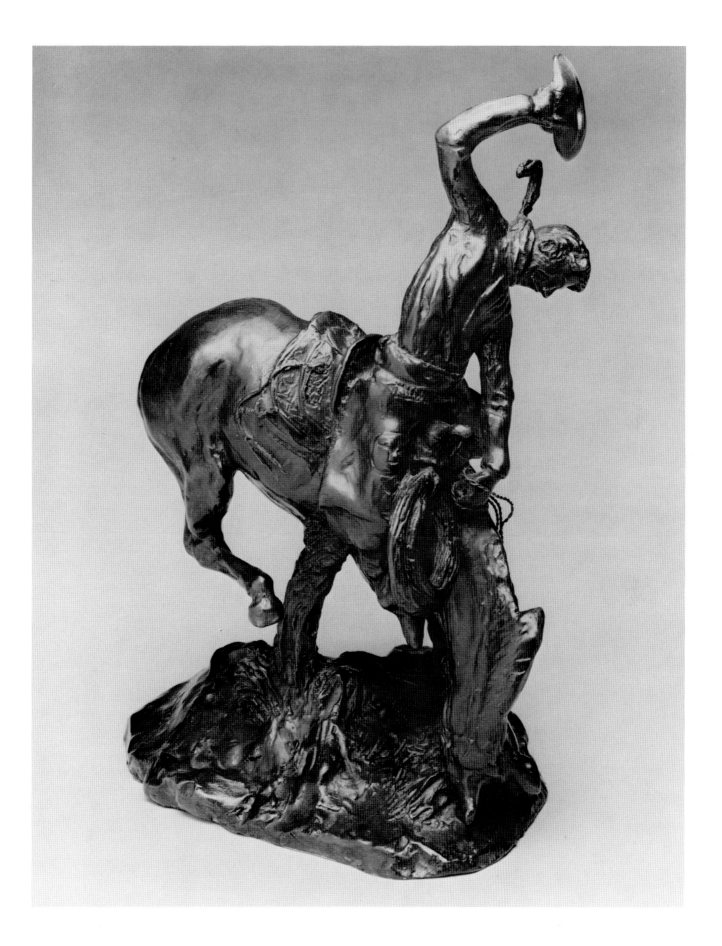

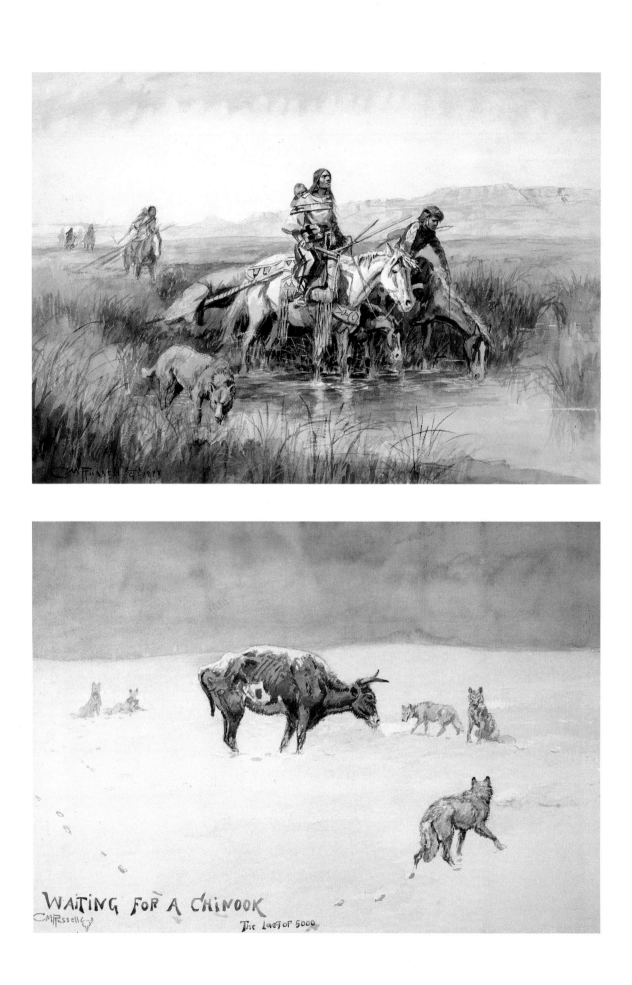

WAITING FOR A CHINOOK

The Last of 5000

Indian women played important roles in a number of Russell paintings, and he produced several paintings of Indian women moving camp. The subject provided the artist with an opportunity to depict the women proudly riding on horseback. He used a composition similar to many of his portrayals of Indian warriors, thus according the same dignity to the women.

Severe storms in the winter of 1886–1887 brought ruin to Montana's cattle industry. When the owners of five thousand head of cattle requested a report on their herd, cowboy Charles Russell simply drew a starving cow about to drop before ravenous coyotes and titled it *Waiting for a Chinook* (a warm, westerly wind). His drawing conveyed the impending disaster more eloquently than any written report. Later he painted this larger version and added the additional title by which the work had become known, *The Last of 5,000*.

addressing the serious problem of stealing, has a wry tone to its title that reflects the representation. *Roping a Grizzly* (*page 59*) shows that Russell, even at a relatively early point in his career, could create action-filled scenes. He used quickly drawn lines to convey the urgency of the moment. Fomal tension is established in the wide-open landscape by taut counterpoising of the bear and cowboy.

Although identified with the cowboy, Russell also sensitively represented the American Indian. *Bringing Home the Spoils* (*page 67*) conveys a sense of the pride of a warrior. *Joe Kipp's Trading Post* (*page 67*) likewise represents a subject not often seen in the iconography of Western art, but one rooted in reality.

Russell also found sculpture to be an appropriate medium for his vision of the West. His sculptures are rarely as monumental as Remington's. Their smaller size makes them appear to have been molded by quick actions of the hand (*page 63*). Many of his works, especially the representations of cowboys on bucking horses, seem to have a nervous energy, which is conveyed by the twisting sculptural lines and the variety of surface detail.

The challenges which Remington and Russell found in the sculptural medium were negotiated by other artists at the turn of the century. The subject of the bucking horse provided a multitude of interpretations because the free movement of the figures made an extraordinary variety of poses possible. Solon Borglum, for example, tipped a horse into a tight composition with the rider creating a strong central axis for the sculpture. Sally James Farnham's *Sunfisher* (*page 72*), on the other hand, has smooth surfaces and is more abstracted. The subject of the Indian as a vanishing race will be forever remembered by James Earle Fraser's sculpture *End of the Trail* (*page 70*), while the elegant lines of Hermon Atkins MacNeil's *The Sun Vow* (*page 71*) create a romantic image of Indian life.

By the turn of the century, a tradition of Western imagery had been firmly established. The demand for Western subjects remained strong, especially for illustrations, but the fresh visions of the early frontier artists had been replaced by iconographic conventions against which artistic efforts could be measured—and against which the supposed reality of the subject matter could be judged.

N. C. Wyeth, for example, had been commissioned to create Western illustrations before he had ever visited the West. His training under well-known illustrator Howard Pyle, however, led him to seek first-hand experience. Three weeks at work on a Colorado ranch in 1904 resulted in a series of paintings focusing on the life of the cowboy. Wyeth then

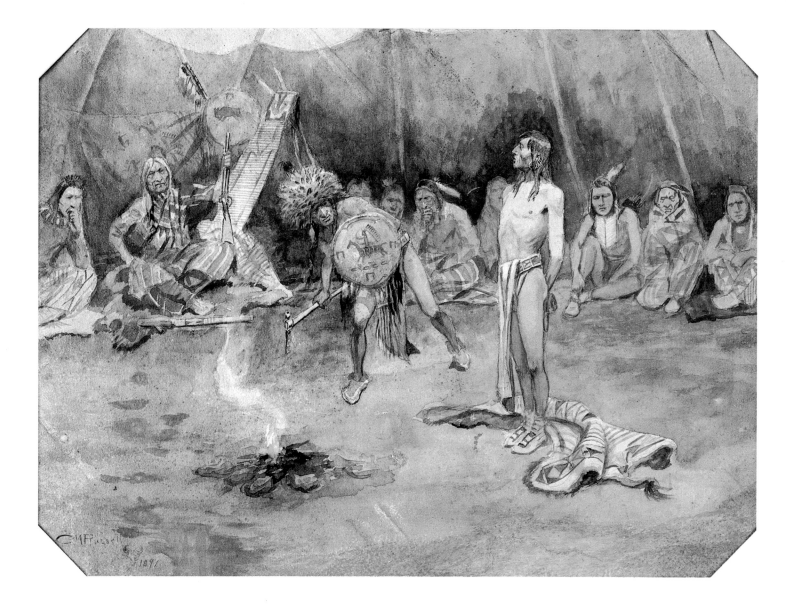

above:
CHARLES M. RUSSELL
Sioux Torturing a Blackfoot Brave
1897. Watercolor on paper, 15 × 20¼"
Gift of William E. Weiss
47.59

In the winter of 1888–1889, Russell lived among the Blood Indians, a band of the Blackfeet in Canada. His time with these people provided a store of images and folklore for him.

opposite top:
CHARLES M. RUSSELL
Bringing Home the Spoils
1909. Oil on canvas, 24 × 36"
Gift of William E. Weiss
19.70

An Indian bringing back bounty from a raid inspired one of Russell's most mature oil paintings. Painted in cool blues and greens, *Bringing Home the Spoils* features the triumphant White Quiver, whose serene mastery of the world is reflected in the dominant position he occupies in the picture.

opposite bottom:
CHARLES M. RUSSELL
Joe Kipp's Trading Post
1898. Watercolor and gouache over pencil, 11¹³/₁₆ × 18"
Gift of Charles Ulrich and Josephine Bay Foundation (by exchange)
1.85

Early in his career as a painter, Russell enjoyed every possible chance to depict a variety of Western types within an individual composition. *Joe Kipp's Trading Post* provided him with the opportunity to portray Western characters in a typical frontier setting. Robes were commonly traded for blankets.

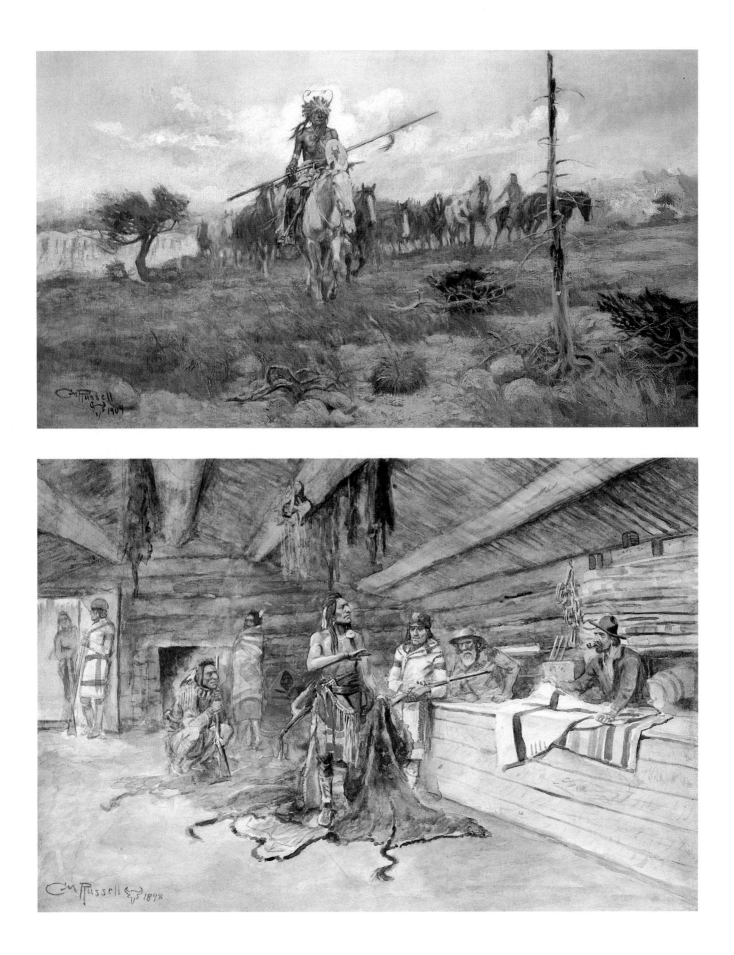

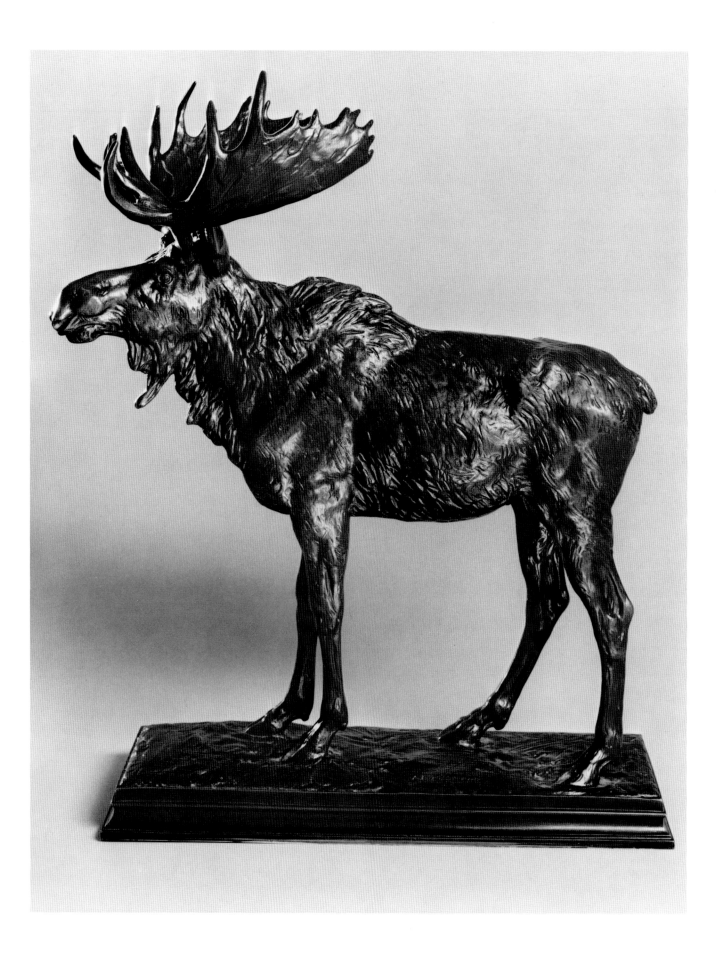

ALEXANDER PHIMISTER PROCTOR (1862–1950)
Moose
Modeled 1893, cast c.1907. Bronze, 19½" high
53.61

For the Columbian Exposition at Chicago in 1893, Proctor made thirty-seven lifesize sculptures of animals and other figures as decoration for the bridges at the fairground. The small models, such as the *Moose*, were later cast in bronze. At the fair, Proctor met Buffalo Bill, whose Wild West exposition was performing there.

HENRY MERWIN SHRADY (1871–1922)
Buffalo
1900. Bronze, 12¼" high
113.67

Shrady, a native New Yorker, studied law at Columbia University and sketched as a pastime. Encouraged to try his hand at sculpting, Shrady had his works cast by the Gorham Company and then devoted himself to the medium. He studied animals, such as the buffalo, at the Bronx Zoo. His most famous work is the Appomattox Memorial Monument to General Ulysses S. Grant in Washington, D.C.

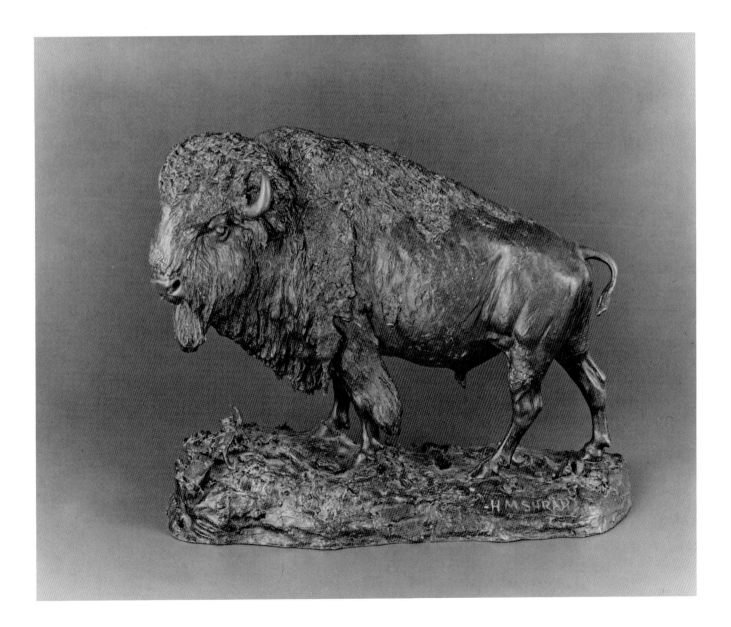

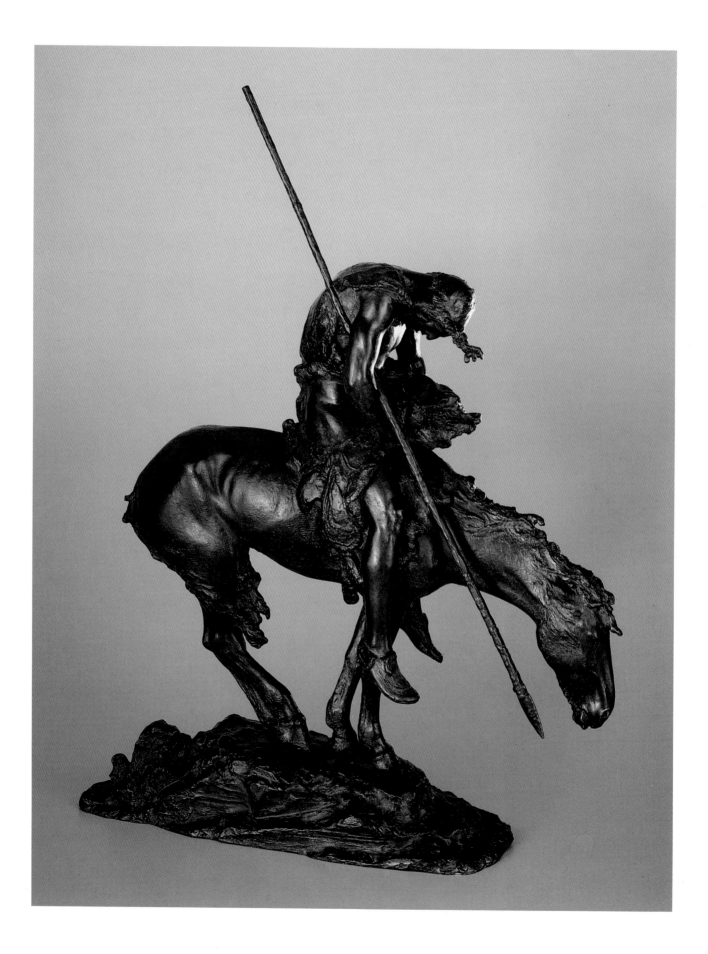

opposite:

JAMES EARLE FRASER
(1876–1953)
End of the Trail
Modeled 1915, cast 1918. Bronze, 33¼"
high (cast by Roman Bronze Works)
Clara Peck Purchase Fund
51.72

The dejected warrior and his dispirited mount symbolize the Indians' tragic fate. Fraser's conception took several forms. He first modeled this subject in 1898, then executed a heroic-sized version in 1915 for the Panama-Pacific Exhibition. Smaller versions were later cast, including this one, which is inscribed "For my friend Warren Delano."

right:

HERMON ATKINS MACNEIL
(1866–1947)
The Sun Vow
Modeled 1899. Bronze, 34¼" high (cast
by Roman Bronze Works)
Gift of William F. Davidson and John
Cunningham by exchange
4.66

The smooth, lithe form of the young boy lends an elegance to MacNeil's sculptural representation of an Indian myth. The continuing traditions of Indian life and the closeness of the family are suggested through the united forms of the elder and younger Indians.

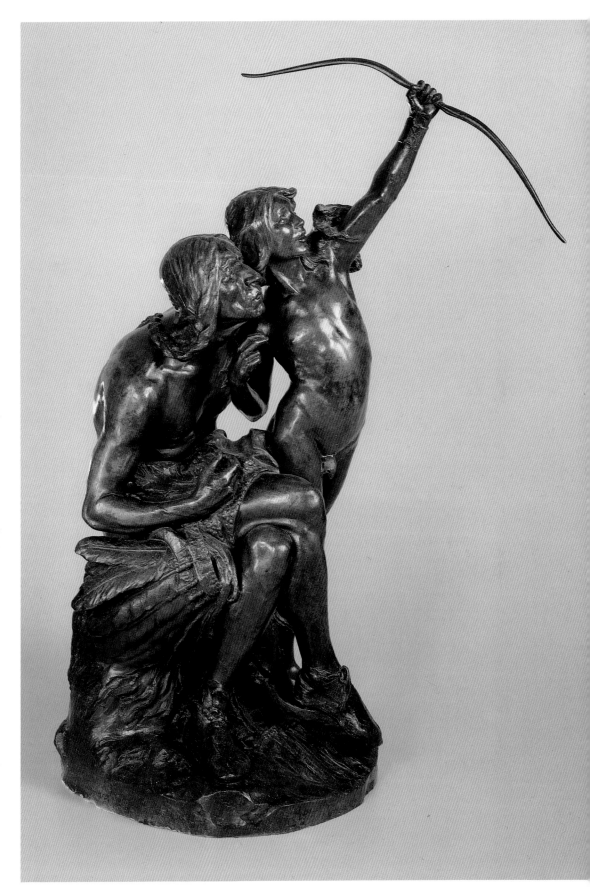

formed a story about his paintings that Scribner's published as "A Day with the Round-up." *The Lee of the Grub-Wagon* (*page 76*) begins the narrative and draws the viewer into the group huddled near the grub-wagon for breakfast. In the series' next illustration (*page 75*), the wrangler roping his mount for the day dominates the foreground and is coiled to break into action amidst the clouds of dust raised by the horses. The balance of the series continues the narrative through the daily life of the cowboy.

Although Wyeth did not maintain his interest in illustrating the West, his approach appealed to other illustrators. W. H. D. Koerner, who filled his New Jersey studio with objects from the West, gained success as a Western illustrator without ever traveling west of the Mississippi. His *Madonna of the Prairie* (*page 77*), painted as a cover illustration for Emerson Hough's novel *The Covered Wagon*, was a beatific image of the pioneer woman. Koerner's illustration then influenced other renditions of the West because it became the basis for the characterization of the heroine in the filmed version of *The Covered Wagon*. Having created visions of the West using only his props and the literary sources he illustrated, Koerner was eventually inspired to travel out to Montana, where he vacationed with his family and collected new items for his studio.

The twentieth-century West, however, inspired more artists to choose, like Charles Russell, to live there. Yet the impulse to collect objects for the studio and to create an emblematic environment remained strong. Joseph Henry Sharp, one of the founders of the famous artists' colony in Taos, New Mexico, found visual inspiration in the rugged northern climate of Montana, where he lived in a log cabin on the Crow reservation. He filled his cabin with Indian artifacts and other objects, from Navajo rugs on the floor to an elk antler chandelier. The accessories he had collected in his Montana cabin and in his Taos studio appear again and again in his paintings (*page 81*).

While most artists chose to visit or move to the West, the early twentieth century also saw the rise of artists who were natives of the West. J. Edward Borein and Maynard Dixon were both born in California and worked as cowboys on ranches. They teamed up for a sketching expedition together, but they developed quite different stylistic approaches. Borein uséd tight, active lines (*page 82*) to convey his cowboys. Dixon ventured toward more painterly efforts and is known for his brilliant palette (*page 85*).

As the twentieth century progressed, the United States developed a society that could support the arts in a variety of

Sally Farnham was a friend and colleague of Frederic Remington who devoted her artistic life to making sculptures of Western subject matter. *The Sunfisher* was cast around 1920. Less formal and academic than Remington's work of a similar theme (*page 50*), Farnham's bronze is as spirited as the cowboy and bronco that she depicts.

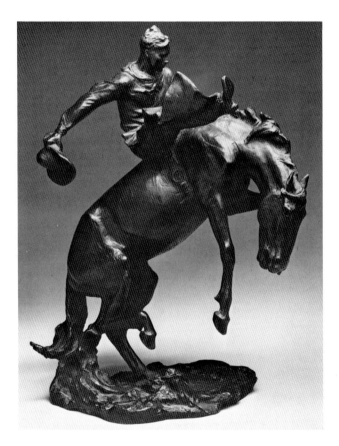

SOLON H. BORGLUM
(1868–1922)
One in a Thousand
(The Bronco Buster)
1900. Bronze, 42" high (cast by
Gorham Co.)
Gertrude Vanderbilt Whitney Trust Fund
6.60

The son of Danish immigrants who went to the West in search of religious tolerance, Borglum grew up on the prairies of Nebraska. He followed the footsteps of his elder brother Gutzon in becoming a sculptor, and the two became artistic rivals. Both studied in Paris, but they retained a preference for American subjects—such as this dynamic representation of a bronco buster.

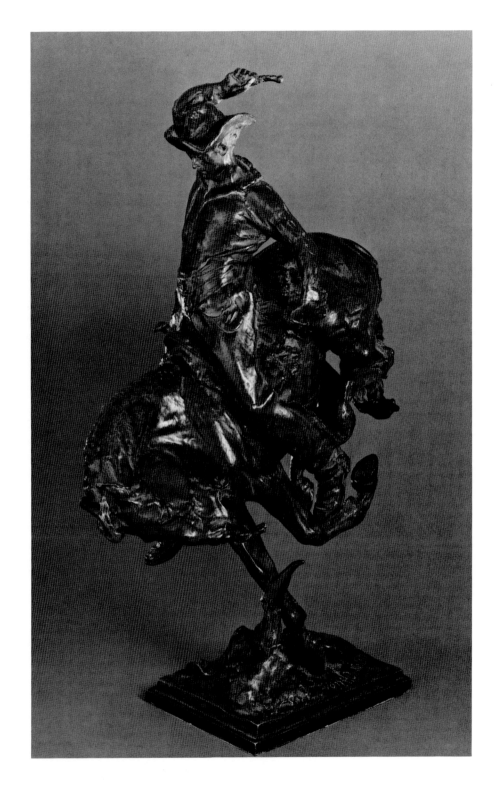

above:
OLAF C. SELTZER
(1877–1957)
Watching for the White Man's Boats
Undated. Oil on canvas, 42¼ × 53¾"
8.75

Russell's influence is revealed in Seltzer's sympathetic *Watching for the White Man's Boats*. Born in Copenhagen, Denmark, Seltzer emigrated to Montana in 1892, where he worked for horse outfits and then for the Great Northern Railway as a machinist. Russell, whom he met in 1897, helped transform Seltzer's artistic interests from a pastime into a career. They often painted together, and *Watching for the White Man's Boats* reflects the influence of Russell's palette and brushwork, as well as his subject matter. Both artists were concerned about the demise of the Indian. In this work, Seltzer shows his sympathy for the Indian, setting his vulnerable subject against the turquoise and soft yellow and pinks of an evening sky, on the lookout for intruders.

opposite:
N. C. WYETH
(1882–1945)
Above the Sea of Round, Shiny Backs the Thin Loops Swirled and Shot into Volumes of Dust (R-G, Colorado)
1904. Oil on canvas, 38¼ × 26"
Gift of John M. Schiff
3.77

Wyeth described the excitement of saddling: "In the corral the horses surged from one side to the other, crowding and crushing within the small rope circle. Above the sea of round, shiny backs, the thin loops swirled and shot into volumes of dust, the men wound in and out of the restless mass, their keen eyes always following the chosen mounts."

ways. The changing social climate brought with it an acceptance of modern painting and abstractionism. Some Western artists, such as William R. Leigh, railed against the avantgarde. His *Panning Gold, Wyoming* (*page 85*) reveals in its style the artist's traditional academic interest in painting the figure. Others, like Carl Rungius, resolved the new aesthetic tendencies within the traditional Western illustration format by experimenting with painterly techniques for representing his subject. He found a particular audience for his big game pictures in the hunters who sought the same bounty. How-

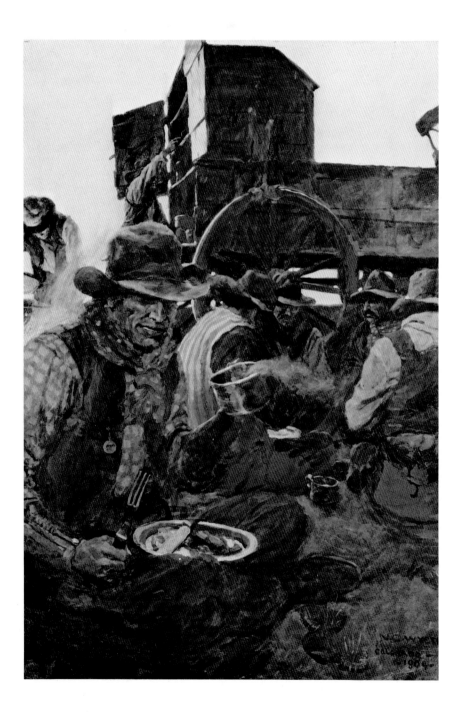

N.C. WYETH
The Lee of the Grub-Wagon (Colorado)
1904. Oil on canvas, 38 × 26"
Gift of John M. Schiff
46.83

In 1904 N. C. Wyeth made his first trip out West. He worked for three weeks on a cattle roundup, which provided the inspiration for a series of paintings about cowboys. The artist used his pictures to accompany a story, "A Day at the Roundup," he wrote for *Scribner's* magazine.

W. H. D. KOERNER
(1878–1938)
Madonna of the Prairie
1922. Oil on canvas, 37 × 28¾"
25.77

Heroine of *The Covered Wagon*,
Molly Wingate traveled the Oregon Trail
with a wagon train of settlers. Encoun-
tering prairie fires and Indian ar-
rows, the beautiful maiden eventually
reached Oregon, where, in the conven-
tions of popular fiction, she found true
love. In this illustration for the book
jacket of the novel, Koerner used the
covered wagon to form a halo around
the head of the young pioneer.

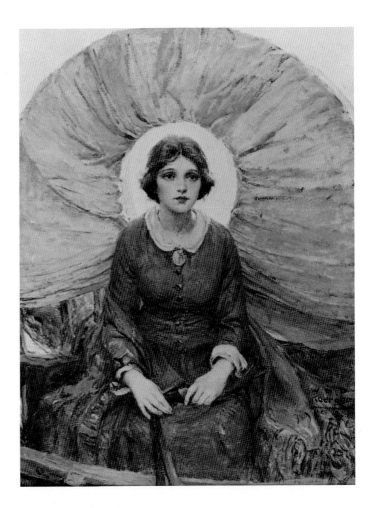

W. H. D. KOERNER IN HIS
INTERLAKEN, NEW JERSEY,
STUDIO

Koerner's studio, which he de-
signed, is reconstructed in the Whitney
Gallery of Western Art. In nearby stor-
age rooms he kept costumes that could
be worn by posing models. A barrel
made a good substitute for a mount,
and authentic objects from the West in-
creased the verisimilitude of his
illustrations.

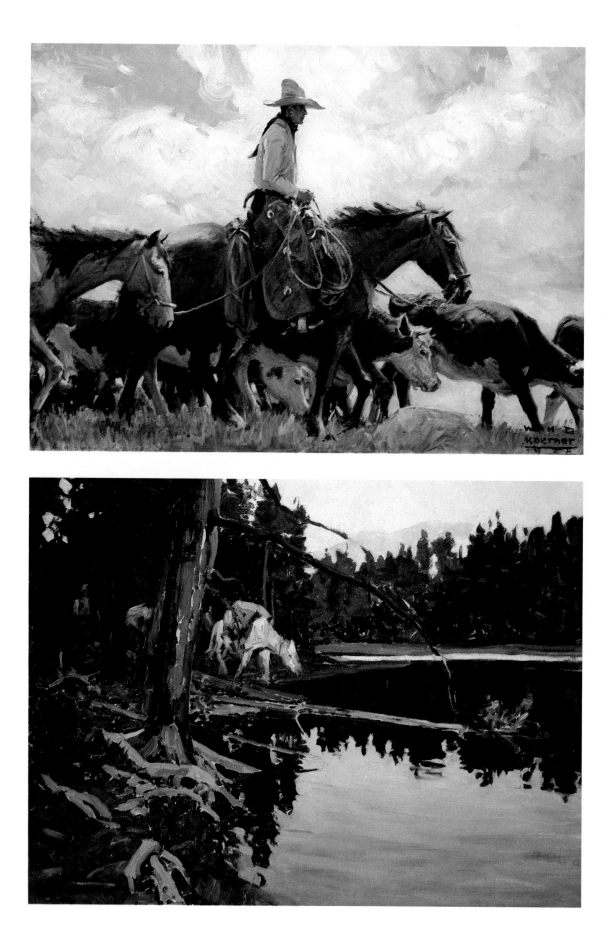

W. H. D. KOERNER
They Stood There Watching Him Move Across the Range, Leading His Pack Horse
1928. Oil on canvas, 29⅛ × 41"
29.77

In order to illustrate the short story "Post Office at Dry Fork" by Hal G. Evarts in the November 3, 1928, issue of the *Saturday Evening Post*, Koerner used his studio props to represent the costume of cowboy Bud Crandall. The laconic cowboy with his small herd of cattle followed schoolteacher Miss Abby Howard from Wyoming town to Wyoming town.

FRANK TENNEY JOHNSON
(1874–1939)
Cove in Yellowstone Park
c.1938. Oil on canvas, 30 × 40"
Gift of Fred and Sara Machetanz
2.82

From 1931 to 1938 Frank Tenney Johnson spent his summers at the Rimrock Ranch, approximately thirty miles east of Yellowstone National Park. From the ranch, Johnson would hike up the canyons along the rivers, pack into the mountains, and camp in Yellowstone to explore, sketch, and paint. *Cove in Yellowstone Park*, from one of his painting excursions, is probably unfinished. Using broad, loose brush strokes, Johnson worked quickly to render a glimpse of the park's beauty.

JOHN HENRY TWACHTMAN
(1853–1902)
Waterfall in Yellowstone
c.1895. Oil on canvas, 23⅜ × 16½"
Gift of Mr. and Mrs. Cornelius Vanderbilt Whitney
22.69

The solid forms of the Yellowstone Canyon walls seemingly dissolve and have no more solidity than the rushing waterfall in Twachtman's impressionistic painting. This work is based on his one trip out West in 1895, during which Twachtman concentrated on the effects of light on the geological formations.

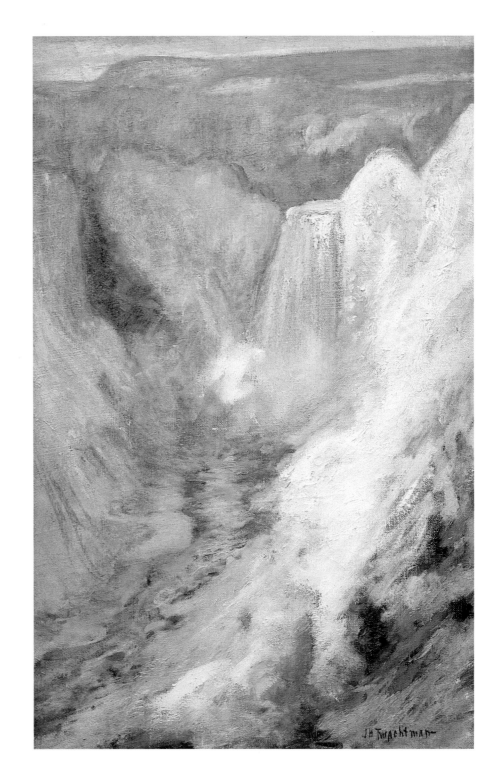

ever, the powerful reality of the hunters' mounted trophies forms an interesting counterpart to Rungius's paintings, in which his painting style makes the animal merge with the landscape.

Through artists' efforts, the Western experience, which had once seemed hostile to the arts, became a rich vein for creative work. The tradition established by the pioneering artists meant that for later painters the West could be imagined almost entirely from props and precedents. For other artists, the West itself remained the source of their creative inspiration. Until the 1950s, the major art centers of our country remained in the East, however, and the movements in American art toward abstraction meant that narrative and landscape artists were, in some ways, out of the mainstream. Yet the pull of the West remains strong to this day—both for artists and patrons—and significant images of Western life and land continue to be generated by artists. The West as a place, as an idea embodied in objects, and as a tradition is still very much a source of inspiration for American art.

JOSEPH HENRY SHARP
Burial Cortege of a Crow Chief
c.1902–1910. Oil on canvas, 27 × 39⅜"
2.61

The gray light of the sky and the colors reflected in the snow create a chilling atmosphere for this painting of a burial. The artist's absorption with the subject of death may be related to his concern for the passing away of Indian traditions.

right:

JOSEPH HENRY SHARP
(1859–1953)
The Warbonnet
Undated. Oil on canvas, 24⅛ × 20⅛"
Gift of the Rockwell Company
24.61

Although Sharp asked individuals to pose with specific items, he was not interested in ethnological veracity and often combined items from different tribes, as in this painting of a warbonnet.

below:

JOSEPH HENRY SHARP
The Broken Bow (Father and Son)
c.1914. Oil on canvas, 44½ × 59"
7.75

The Broken Bow portrays the continuity of Indian traditions, symbolized by the tender relationship between the father and his son.

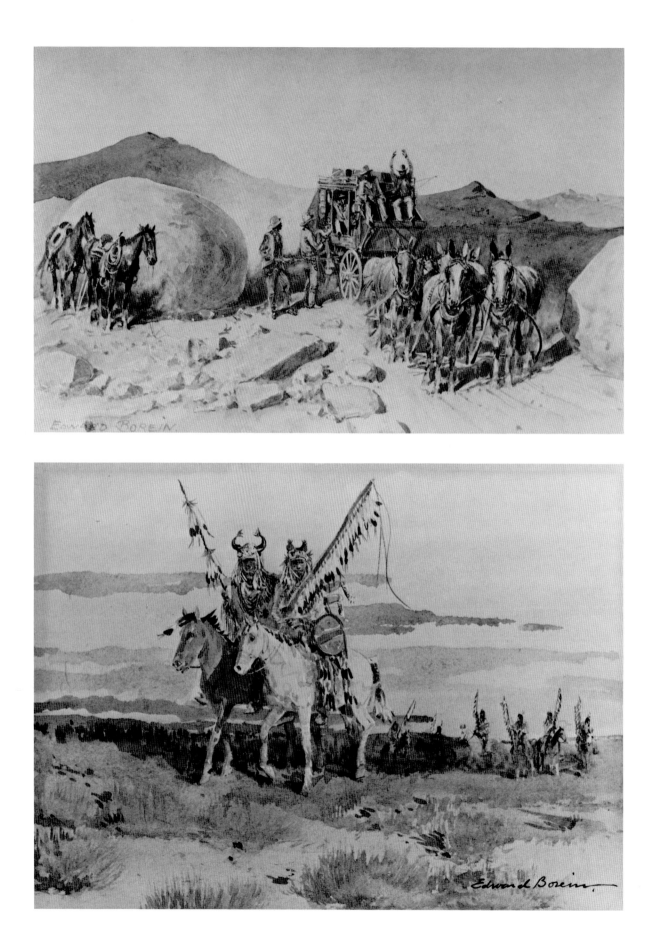

Stagecoaches represented the romance of the Old West to Borein. He wrote: "To those who have ridden on the box with one of the old-time drivers and watched his easy handling of the reins, his confidence in himself and his steeds, as he rounded jutting points and descended steep grades that made the passengers gasp for breath, the memory is a never-to-be-forgotten picture."

An admirer of the work of Charles M. Russell, Borein first met the Montana artist in New York City. Later, Russell helped Borein get an assignment for advertisements of the Calgary Stampede, and Borein traveled with the Russells to that rodeo. Afterward, he went out sketching Indians with Russell.

Picturesque Mexico beckoned cowpuncher-artist Borein several times in his career. With a supply of sketches from his journeys across the border, he eventually moved to New York City to work as an illustrator. He drew this dashing vaquero first as a cover for the Sunday magazine of the *New York Tribune* in 1909 and then repeated the figure in this larger composition.

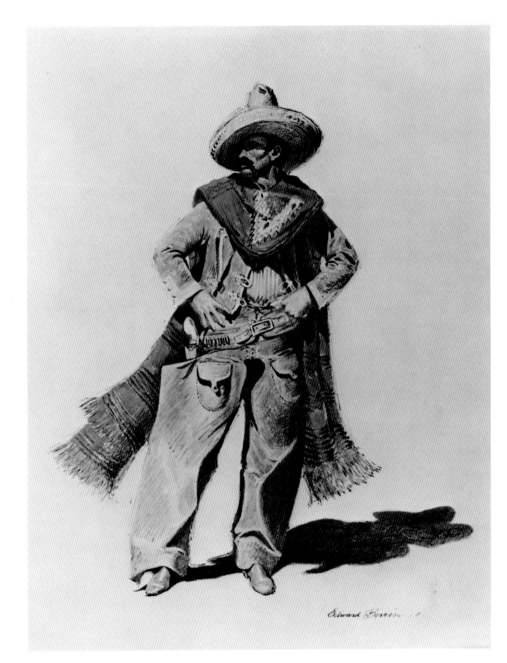

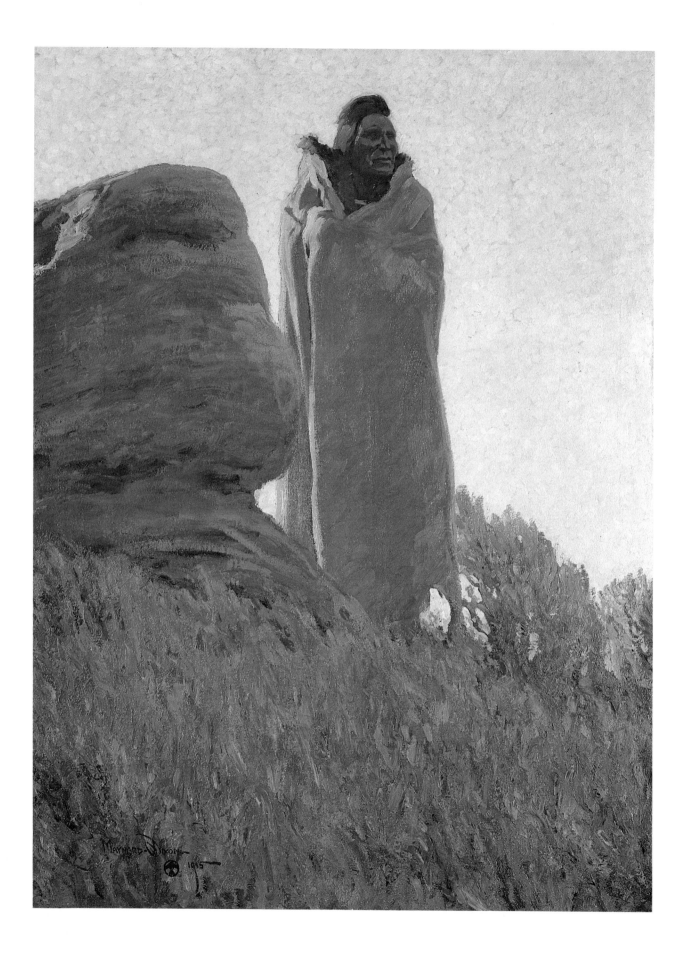

WILLIAM R. LEIGH
(1866–1955)
Panning Gold, Wyoming
1949. Oil on canvas, 32¼×40"
Gift of the artist
1.59

Leigh painted *Panning Gold, Wyoming* late in his life, although the study for the landscape was probably painted on one of his trips to Wyoming early in the century. Although his academic training in Munich often led him to paint his figures in a mannered style, this figure of a miner exhibits a complicated but naturalistic pose.

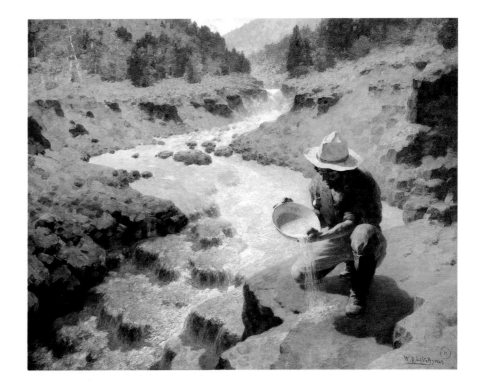

CARL RUNGIUS (1869–1959)
Moose
1946. Oil on canvas, 24×32"
9.73

At an early age, Carl Rungius decided to be an artist, and more specifically, a wildlife artist. Rungius also took every opportunity to study animal anatomy, observing and drawing musculature and bone structure. He was an ardent hunter, and this passion brought him to Wyoming in 1895 as he had been told wildlife was abundant there.

opposite:
MAYNARD DIXON (1875–1946)
The Medicine Robe
1915. Oil on canvas, 40×30"
Gift of Mr. and Mrs. Godwin Pelissero
2.73

The searing light in the desert inspired Dixon's most accomplished views of the Indian. *The Medicine Robe* was painted in 1915 after a sketching trip to Arizona, one of Dixon's many productive visits to the Southwest. Influenced by Impressionism, Dixon experimented with loose, free brushwork and broken colors.

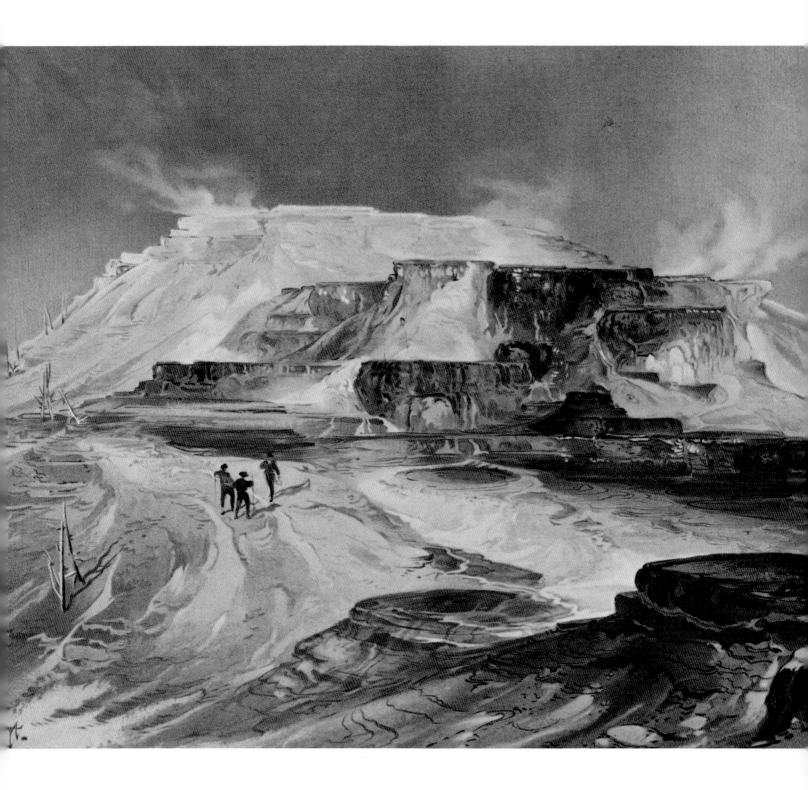

The West and American Unity

German-born Louis Prang was the most famous chromolithographer in the United States in the late nineteenth century. Between 1874 and 1876, Prang commissioned Thomas Moran to paint a series of watercolors of Yellowstone, from which he made folios of chromolithographs. Moran had been to Yellowstone in 1871 as the artist for a government expedition led by Ferdinand Vandeveer Hayden that was assigned to explore the region. On this trip, Moran made hundreds of drawings, watercolor sketches, and color notes that enabled him to recreate the geologic wonders of Yellowstone in his studio paintings and prints. *Mammoth Hot Springs* is one of fifteen lithographs that appeared in Prang's folios.

The men and women who struck out for the western territories did not leave their culture behind. Citizens of the United States—even in the late eighteenth and early nineteenth centuries, when there scarcely was a United States—were conscious of their American identity.

Americans, like people from other nations, adopted certain cultural symbols that helped them identify with their country and their fellow countrymen. Their symbols of unity were newer and fewer than those of Englishmen. They were also mainly political symbols at first, since the United States was (or "the United States *were*," as people of the era would have said) a political rather than a racial or cultural or geographical union. The most important symbols were the Fourth of July, the Constitution, and George Washington.

East and West, Independence Day was celebrated with gusto. It was a national festival, the reminder of America's origins. It was both a martial and social occasion. Wherever they found themselves on that day, Americans fired guns and drank toasts, acknowledging that independence was won by force of arms and expressing fellowship with their countrymen.

The U. S. Constitution was tangible proof of the ascendance of law and reason. For those moving West, who could and did carry copies of the document, it was particularly important because it provided for the extension of the nation and the creation of new states. Its power to unite people was such that, as early as 1812, Louisiana could join the Union despite being separated by hundreds of miles from the nearest state.

The most widely honored symbol of all was George Washington. Newspapers in the 1790s called him "the eighth wonder of the world." His steadfast republicanism, his integrity, and his heroic deeds made him a model for all

Americans. In fact, it was a source of pride for citizens of the new nation to be able to call themselves the countrymen of George Washington. Furthermore, his own pursuits and youthful career in the Ohio Valley West made him the inspirational patron for westering America. Whether toasting the Fourth of July or their safe arrival in a new place, Americans would raise their cups first to George Washington.

Pioneers in the western territories were not trying to create new societies. Usually they set out to replicate the social and political forms they had left behind. Their homes and towns were practical adaptations of the styles and technologies with which they were most familiar. Even those Easterners most fearful of expansion were generally reassured when they saw the rapid strides Westerners made in building American institutions. The common bonds were apparent.

In 1790, Yankee geographer Jedediah Morse observed that in the new societies of the West men would become *more* American. He predicted that over generations regional and cultural differences would be blended into a distinctly American identity. By the 1830s, a nascent theory of the frontier influence on American character was articulated. In the 1837 edition of his *Guide for Emigrants*, John Mason Peck wrote, "the rough, sturdy habits of the backwoodsmen, living in that plenty which depends on God and nature, have laid the foundation of independent thought and feeling deep in the minds of Western people." And the numbers of Western people were rapidly growing.

Within ten more years, the United States had annexed Texas and was contending with Mexico and Great Britain for the rest of the West. Historian Bernard DeVoto called 1846 "the year of decision" because Americans decided then to be a continental nation. In 1850, only four years after declaring war on Mexico and two years after the discovery of gold, the U.S. admitted California to statehood, extending the Union from coast to coast.

By 1853—through purchase and conquest, but mainly through the inexorable westward movement of people—the U.S. had acquired all the territory that would become the lower forty-eight states. The settlement of the Far West became the focus of national attention and, ironically, a source of both division and unity. The furious controversy over efforts to open the West to slavery threatened to split the Union. At the same time, as if updating Jedediah Morse's pronouncement, a newspaper editor in Missouri wrote: "There is a certain universality in the type of the Western man...the Virginian, the Yankee recognize each his own

IRVING R. BACON
(1875–1962)
The Conquest of the Prairie
1908. Oil on canvas, 47¼ × 118½"
Gift of the Newells
14.64

The Conquest of the Prairie glorifies William F. "Buffalo Bill" Cody as civilization's guide. Cody leads a wagon train across the prairies as Indians passively and peacefully watch. In the distance gleams the future—an industrialized city. Bacon received his artistic training in Munich, where this work was painted, and later was commissioned to create paintings and designs for Henry Ford.

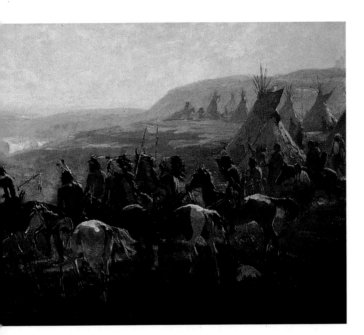

image in the many-sided man of the West. They feel they have certain affinities for him, though they have none for each other."

During the contentious era of Reconstruction, the entire nation again looked West. In the aftermath of the Civil War, there were at least three mutually alienated constituencies in the United States—the people of the North, the people of the South, and the newly arrived immigrants from Europe. After the Civil War, the immigrant population of the United States grew from a total of 5.7 million in 1870 to over 10 million in 1900. Many of the new arrivals headed west to the frontier. The West became a destination for the landless, the disaffected, and the ambitious—and a force for American unity.

By the end of 1867, ten states had been formed west of the Mississippi, but the United States government exercised power in comparatively little of the western territory. In fact, not only did the federal government have the problem of extending authority over local governments and alliances formed by settlers throughout the West, it also faced the difficulty of exercising control over the many independent Indian tribes of the Far West. The post–Civil War army was too small to bring military order to the West. The federal government had to rely on political and economic self-interest and nationalistic sentiments for unity in the West. Most important, the western territories were owned and governed by all of the United States, including those states undergoing reconstruction. Thus, Americans—Virginians, Yankees, or immigrants—nominally had an equal stake in the West, where there was at least the appearance of equal political and economic opportunities.

Certainly, public interest in the West was high. Between 1860 and 1898, two-thirds of the dime novels published by the New York firm of Beadle and Adams were set in the trans-Mississippi West. Most of the popular magazines of the day published features dealing with Western issues and were illustrated by artists who were familiar with Western settings. Certain events and experiences—the rendezvous, the survey, the transcontinental railroad, the Pony Express, the Oregon Trail—grew to stand for the whole of America's westward movement. The winning of the West became a new national myth. The Indian and the landscape were conquered—without opposition the "winning of the West" would have been a hollow victory—and an unbroken succession of explorers, heroes, and villains helped to focus attention on the frontier-to-statehood epic. Nothing has supplanted this rich narrative in the American imagination.

As history, it is so recent that parts of the story extend into our parents' and grandparents' experiences. Even today, homesteading has not entirely ceased; cowboys still ride the range; there are still wilderness areas to explore. A resurgence of Indian self-awareness also has led to the renewal of rituals and traditional observances by most Western tribes.

The visual record is vast and excellent—many of America's finest nineteenth-century painters found inspiration in the West—and the physical record is substantial as well. Numerous and important objects survive from every era of Western history, and they serve not only as visible links to the historic past but also as icons of Western myth.

From the homely to the artistic, from the practical to the frivolous, artifacts are aids to imagining past events and to understanding the lives of the participants. Many objects— the Kentucky rifle (*page 93*), the stagecoach, the warbonnet (*page 111*)—are in themselves enough to stir in us a feeling for the whole epic.

EXPLORERS AND TRAPPERS

Western exploration was first the province of the Spanish and the French. Both private and government-sponsored expeditions found and named the rivers and deserts of western America, usually during the search for one kind of gold or another.

Distances were measured and mapped according to the scientific knowledge and technological sophistication of the time. During his mid-sixteenth-century march through the Southwest, Coronado assigned two soldiers the task of counting their steps. By the mid-nineteenth century, however, U. S. Army surveyors strapped leather-bound odometers with brass works to their wagon wheels.

The quest for riches energized the early explorers. The French, and the English and Americans in their wake, were after fur-bearing animals, which by the end of the seventeenth century had been hunted virtually into extinction on the Eastern seaboard. The French *voyageurs* and *coureurs-des-bois* who hunted in the interior were the antecedents of the American mountain men. Many were veterans of European wars and had come to North America with a lust for adventure and danger. They adapted easily to life in the woodlands and cultivated Indian friendships for purposes of trade.

It was the fur trade that led Pierre Esprit Radisson and his brother-in-law Médard Chouart, sieur des Groseilliers, to

The beaver was one of the first of America's resources to be commercially exploited. By the end of the seventeenth century it was virtually extinct in New England and the Northeast. The quest for its pelt drew Europeans and Americans westward, particularly when the beaver hat became a staple of men's fashion.

The potential gain for the trapper/entrepreneur was great. One dried beaver hide—the plew (shown here)—generally weighed less than two pounds. A pack of sixty plews might be worth as much as six hundred dollars.

Hundreds of thousands of beaver were trapped by devices like this Victor No. 4, a successor to the Oneida Community's famed Newhouse traps. It weighs about three pounds. The first traps manufactured by Sewell Newhouse in the 1820s were modeled after a pattern developed in the previous century. Felt manufactured from beaver fur was used to make hats, such as the one shown here with its leather traveling case.

the shores of Lake Superior in the 1650s (*page 56*). They were the first Europeans to visit what is now Minnesota, and they returned to Montreal with huge quantities of furs. Because of licensing technicalities, French authorities confiscated their cargo. Radisson and Groseilliers promptly switched their allegiance to England and were instrumental in the founding of the Hudson's Bay Company, the legendary mercantile arm of English imperialism.

The Hudson's Bay Company was chartered as a monopoly in 1670 and soon grew powerful enough to strangle all competition east of the northern Great Plains. Throughout the eighteenth century, rival companies mounted expeditions to seek commercially feasible routes to the potential seaports on the Pacific Coast. Frenchmen ascended the Missouri River from St. Louis; Scots and Englishmen struck west from the Great Lakes.

In 1793, Alexander Mackenzie of the North West Company succeeded in reaching the Pacific at present-day Vancouver. However, the difficult portages and unnavigable rivers north of the 49th parallel made his route worthless for commercial prospectors. Undaunted, Mackenzie determined eventually to head south into what is now the United States—beyond the reach of the Hudson's Bay Company.

In 1792, however, Robert Gray, an American captain, had discovered the mouth of the great river that he named for his ship Columbia and sailed upriver to explore and lay claim to the Oregon country. The U. S. thus staked a claim, however tenuous, to the Northwest coast. The U. S. claim was inadvertently protected by the competitive inertia of the Hudson's Bay Company, which refused to assist the efforts of Mackenzie and the North West Company, and by the Napoleonic Wars, which consumed the energies of the French and English governments.

Other Americans were also anxious to chart and explore the unknown territory beyond the Mississippi River. In the 1790s, Thomas Jefferson had advocated sending scientific expeditions into the interior of North America, and he was particularly intrigued by the possibility of finding a water passageway to the Pacific. In 1803, as president, he took advantage of the opportunity presented by the purchase of Louisiana to launch captains Meriwether Lewis and William Clark into the unknown with their "Corps of Discovery."

below:

Water is the arid West's most precious commodity. On their treks to the Green River beaver country or to southwestern centers of Indian trade, travelers might have to spend days between sources of fresh water. Canteens and other containers were essential. The water jug pictured here was fashioned from a single gourd. It is lightly etched with battle scenes that suggest its Mexican owner may have been a soldier.

In the eighteenth and early nineteenth centuries, Pennsylvania gunmakers combined precision and art to produce flintlock "Kentucky" (because they were made famous by their use in that region) rifles such as this one, which has a brass patch box and tiger-striped maple stock.

The Lewis and Clark expedition is the archetypal voyage of discovery in America. Its stature rests not least upon its successful fulfillment of several competing purposes, including those of commerce, diplomacy, science, and literature. Lewis and Clark reaffirmed the American claim to Oregon, spending the winter of 1805–1806 at a camp named Fort Clatsop, which they built near the mouth of the Columbia River. They established the first official American contact with the northern Plains tribes, stocked Peale's Museum with animal and plant specimens, sent back enough furs to pique mercantile interest, and described it all in classic journals of discovery.

Adding drama and social importance to the expedition was the United States's acquisition of the Louisiana Territory itself. It was unmapped and largely unknown. Its immensity could only be guessed at. Critics of the purchase feared that Americans would be sucked into "a vast maelstrom," depopulating the East and leading to social chaos. Their fears were fueled when Lewis and Clark were not heard from for over a year. But when the explorers returned, they had not only confirmed the vastness of the American interior, they had also reduced the unknown to a mappable scale.

There were other ways in which the expedition appealed to Americans' imaginations. First, there was the great collaboration itself, the almost mystical friendship of Lewis and Clark. Not only did Lewis and Clark like and admire each

other, they unselfishly divided responsibility and authority, and they shared equally in the credit and the hardship. Next, there was the contribution of Sacagawea, the young Shoshone heiress to the legends of Squanto and Pocahontas. The success of the expedition also sustained the reputation and contributed to the myth of American woodcraft. Lewis and Clark were elevated into the company of Benjamin Church, the young George Washington, George Rogers Clark (Clark's older brother), and Daniel Boone. The captains also credited American technology and the Yankee ingenuity of the soldiers in their corps, who overcame numerous engineering obstacles.

Moreover, as the expedition was not recorded by an official artist, American painters were free to choose from the narrative's details in creating their own visions of discovery. One of the major renditions is Thomas Burnham's 1838 oil painting, which shows Lewis and Clark in an almost subtropical setting (*page 36*). This was considered appropriate, if factually inaccurate, because the expedition opened up what was perceived to be the garden of the New World. Naturally, Lewis and Clark almost always have been depicted together, although in fact they spent much of their time on separate explorations. Sacagawea has often been included in artists' portrayals, usually carrying her infant son, Pompey, who was born during the expedition.

The memory of the triumphs of Lewis and Clark is fortunately untainted by the politically inspired "poetry" that appeared in their honor. Republican poet John Barlow rushed into print with an epic, "On the Discoveries of Lewis," in which the refrain urges renaming the Columbia River:

> Let our Occident stream bear the young hero's name
> > Who taught him his path to the sea.

Barlow was answered by the anti-Republican John Quincy Adams, who did not dispute the privilege of the discoverers to name the unnamed, but wrote:

> > And Barlow stanzas shall indite—
> > A bard, the tide who tames, sir—
> > And if we cannot alter *things*
> > By God, we'll change their *names*, sir!

American mountain men, the adventurous trappers who spent their careers learning the wilderness, were also among the greatest American explorers. The first of these men were members of the Lewis and Clark party. John Colter left the expedition with the blessing of the leaders in order to

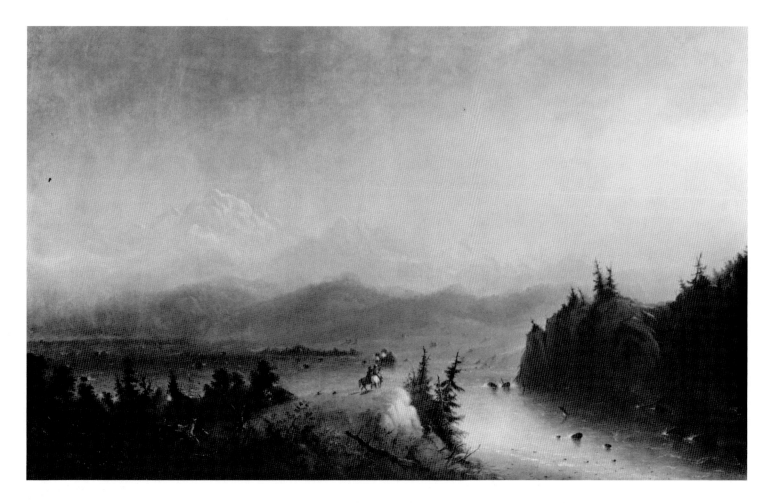

ALFRED JACOB MILLER
Trappers Saluting the
Rocky Mountains
c.1864. Oil on canvas, 25 × 38⅞"
Gift of The Coe Foundation
10.70

Stewart and Miller knew this
range as "The Mountains of the Wind,"
and when the artist painted this grand
scene many years after his trip West,
he made every effort to recall the epic
scale of that distant panorama. The
mountain men, diminutively portrayed
in the foreground, discharge their rifles
in celebration of nature's splendor.

accompany two trappers up the Missouri River. Colter was the
first white man to pass through the Bighorn Basin of Wyo-
ming, and he discovered the geyser basin near present-day
Cody that came to be known as Colter's Hell. His stories of
Yellowstone's geysers no doubt contributed to the mountain
man's reputation for spinning tall tales.

The greatest mountain men were also the greatest
trailblazers: Jedediah Smith, Joseph Reddeford Walker, Jim
Bridger, Kit Carson, like most of their confreres, had gone
West as employees of fur trade entrepreneurs. They became
free trappers or formed partnerships and trade combines.
They adapted quickly to Indian ways and dress, many of them
taking Indian wives. They brought their superior firearms with
them: the beautiful Pennsylvania-crafted Kentucky rifles with
birdseye or tiger maple stocks and legendary accuracy (*page
93*) or the more practical and powerful Plains rifles, among
the best of which were those made by the Hawken brothers of
St. Louis (*page 96*). They carried a sack or string of steel traps
with single or double springs (*page 91*), a horn and pouch, and
a "possibles" bag (in which it was possible to find almost any-

Traders and trappers were among the first white men to penetrate the western wilderness. Carrying their "possibles" bags and powder horns and armed with reliable weapons, such as the Hawken rifle (bottom) and pistol shown here, they either fought or befriended the Indian people they met.

Pictured with the gear are a wool blanket and trade gun (with the distinctive brass serpent), symbols of both commerce and warfare. The flintlock musket was manufactured especially for the Hudson's Bay Company to trade to its Indian clients. The versatile blanket, so coveted by northern tribes, could also be an instrument of germ warfare when deliberately infected with smallpox and left for the unsuspecting.

thing). Dressed in fringed or beaded buckskin shirts and trousers, they lived a rugged outdoor life that would come to appear picturesque and romantic to the artist's eye (*page 33*).

The event that best symbolizes the mountain man's era for us is the rendezvous, the annual get-together of traders and trappers. William Ashley staged the first of the Green River rendezvous south of Jackson's Hole on the western slopes of the Wind River Mountains. Ashley's Rocky Mountain Fur Company bought beaver pelts in exchange for powder and lead, tobacco, liquor, and other goods hauled in by wagon. The rendezvous became an occasion for games, talk, and good cheer for the trappers and their Indian friends.

We especially remember the Green River rendezvous of 1837—one of the last—because of the presence of the artist Alfred Jacob Miller. Hired by Scottish sportsman and adventurer Captain William Drummond Stewart, Miller was the only trained artist actually present at a mountain man rendezvous. Unlike Burnham's imaginative stab at the Lewis and Clark expedition, Miller's paintings were founded on observation but nonetheless were romantic in execution. Miller's oil rendering of *Trappers Saluting the Rocky Mountains*, for instance, avoids Burnham's geographical fantasy but still grandly represents the sublime landscapes popular in American painting at mid-century (*page 95*).

Their romanticism notwithstanding, Miller and his daring contemporaries George Catlin and Karl Bodmer provided invaluable ethnographic documents of their era. Catlin's portfolio of Indian portraits and landscapes, begun on a trip—by steamboat—up the Missouri River in 1832, fed the curiosity of American and European audiences, for whom the exotic West was becoming not only intriguing but accessible. Bodmer went up the Missouri in 1833 in the company of Austrian Prince Maximilian. A romantic adventurer, Maximilian fancied himself an explorer in the mold of scientist Alexander von Humboldt, whose South American expeditions a generation before had begun the era of scientific exploration. Bodmer's exacting drawings of the Indians he encountered are among the finest visual records of the styles and customs of the era.

The age of private exploration began to wane as the demand for beaver declined and pressure mounted to open public lands for settlement. Government-sponsored expeditions continued to survey and map the West. They hired some of the best mountain men as guides, and they all employed professional artists. The government surveys created new heroes and new views of the West, increased scientific knowledge, and abetted the tremendous migrations to Oregon and California and finally to the interior West.

THE MILITARY FRONTIER

The American army was forged in the wilderness. From colonial times to almost the last days of the nineteenth century, American soldiers were continually at war with Indians. Although military successes helped wrest the continent away from the Indian, the army saw its role as defensive. This notion stemmed from the religious and cultural compulsion of American settlers to change the land, to clear the forests, and to "bring forth fruit." In the view of many, therefore, the Indians' rights to territory were forfeit because their lands remained, as one writer put it, "in a comparatively useless condition."

The political ramifications were expressed in turn in the Paris negotiations at the close of the American Revolution when John Jay asserted the rights of the newly formed United States to western lands: "With respect to the Indian, we claim the right of preemption; with respect to all other nations, we claim the sovereignty over the territory." Americans assumed the right to occupy all lands not set aside by treaty, and the military assumed the duty to defend them.

In Canada, where a colonial government was established before lands were opened to settlement, military confrontations with Indians were relatively few. But in the U.S., settlement was rapid and independent. In addition, the constitution encouraged the creation of local governments distinct from central authority. As the representative of the federal authority, the army played the role of a national police force.

Before the Civil War, this job was difficult enough as the army also had to explore and map the West, police the country's borders, and act for the government in distant outposts. After the Civil War, the difficulties intensified. Four years of warfare resulted in a clamor for demobilization and troop reductions. General Philip Sheridan complained that in 1868 the army had only 2,600 regulars on the Great Plains. By 1874, total army strength had fallen to just 19,000 men. At the same time, the demands on the military grew. Besides manning coastal fortifications and doing Reconstruction duty in the South, the army patrolled the Santa Fe Trail, the Oregon Trail, and the Bozeman Trail to Montana's gold fields. It also had to protect railroad workers and to guard the telegraph; to provide escorts for scientific expeditions and to entertain visiting dignitaries; and it was charged with administering the first national park, Yellowstone. The army's duties on occasion also included expelling white intruders from Indian lands, mediating intertribal disputes, and distributing rations to Indian people on reservations.

The tools of Plains warfare changed little from the Civil War to Wounded Knee. The McClellan saddle, the saber, the cheaply made campaign hat, and the brass and leather-bound telescope are recognizable government issue.

The Spencer repeating carbine gradually fell out of use when the company went bankrupt in 1869. It was replaced by the single-shot Springfield. Winchester's products, however, were eagerly adopted by military officers who could afford to buy their own ammunition. This model 1866 Winchester is decorated with brass tacks—evidence of Indian ownership of the new firearms.

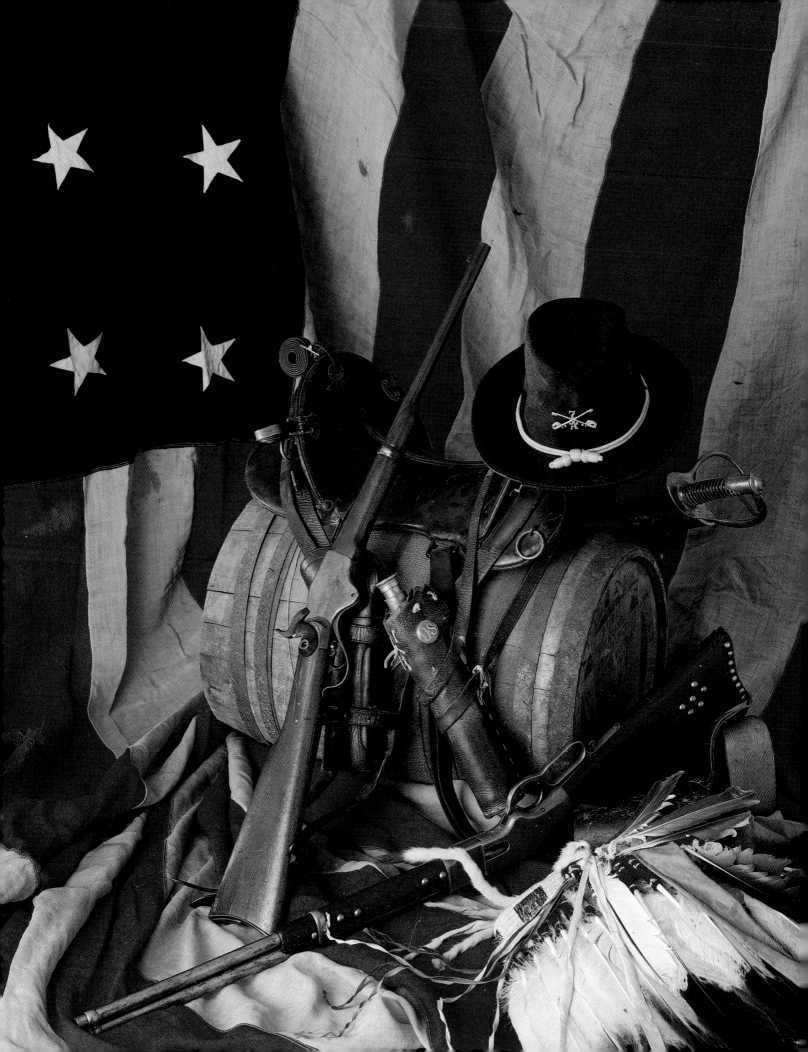

Spread thin along the vast borderlands, the military relied to an extraordinary degree on the quickness and fortitude of the cavalry and on the independent judgment of its officers and non-coms, most of whom were veterans of the Civil War. It also relied on their loyalty and esprit, for the rewards—measured in promotions, pay, and personal glory—were few.

Those who admired the cowboy for his rugged individualism admired the professional soldier for similar heroic qualities. The cavalryman was seen as an agent of chivalry in a hostile environment (*page 104*). Most of the army's campaigns were marked by drudgery, extremes of heat or cold, and little contact with Indians. Other campaigns, such as Colonel Nelson Miles's efforts to end the Bannock and Nez Percé wars in Montana, consisted mostly of dangerous chases over punishing terrain (*page 102*). Few engagements therefore between Indian people and the army captured the public imagination. They lacked the tactical interest, the masses of men, the bloodshed, and the strategic importance of the great Civil War battles. However, two of the most famous fights were represented in paintings: Summit Springs (*page 104*) and the Little Bighorn (*page 105*).

According to some historians, Summit Springs, in 1869, was one of the few fights that would have satisfied Hollywood's cinematic requirements. A Cheyenne warrior society, led by Tall Bull, attacked several homesteads and kidnapped two women in Nebraska. Tall Bull and his "Dog Soldiers" were pursued by General E. A. Carr's 5th Cavalry, which was guided by the 5th's twenty-three-year-old chief scout, William F. Cody. The chase culminated in northeastern Colorado in a galloping charge on the Cheyenne encampment during which Tall Bull was killed, apparently by Cody. Although only one of the two captives was rescued alive, victory was complete for the army and casualties were few.

On the other hand, it was an army defeat by Sioux and Cheyenne people at the Battle of the Little Bighorn that has inspired the most debate and commentary. Lieutenant Colonel George A. Custer's 7th Cavalry was part of a three-column pincer movement designed to surround large numbers of Sioux who were known to be gathering in southeastern Montana. When his scouts found a fresh trail, Custer pushed his troops to overtake the enemy. On the morning of June 25, 1876, Custer divided his regiment into three battalions and ordered an attack. Two of the battalions, led by Major Marcus Reno and Captain Frederick Benteen, were pinned down and besieged. Custer and his battalion—five companies of the 7th Cavalry—were annihilated.

The battle was immediately emblazoned on the public

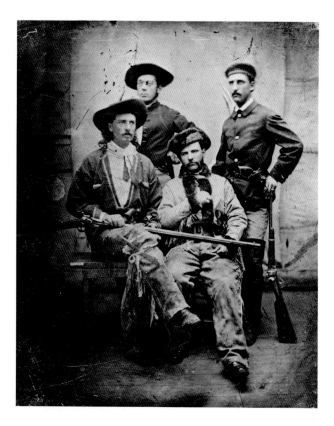

In 1868, twenty-two-year-old William F. Cody was named chief scout of the 5th Cavalry. This photograph, taken at about that time, shows Cody and three unidentified men. Across his lap, Buffalo Bill holds "Lucretia Borgia," his .50 caliber model 1866 Springfield rifle. The hightop boots, broad-brimmed hats, and gear reflect the European chivalric tradition of the Army officer corps and the civilian scouts.

opposite top:

A steel-bladed cavalry officer's sword, probably made around 1875. It is part of Frederic Remington's collection of Western artifacts in the Buffalo Bill Historical Center.

opposite bottom:

This is an 1893 photograph of Buffalo Bill in his showy trappings, which were adaptations and, in some ways, exaggerations of the clothing and accoutrements he had known on the Plains during the Indian wars.

consciousness. It had occurred just as America was congratulating itself on its cultural and technological progress at the Centennial Exposition in Philadelphia and at a time when the nation was beginning to heal from the wounds of Civil War and Reconstruction.

Custer's disaster served to focus the entire nation's attention on the army, the Indian, and the West, and his defeat and death (shortly after he had made headlines for his testimony on the corrupt practices of the Grant administration) were lamented as deeply in the South as in the North. One of the first epic poems on the subject, "Custer's Immortality" by Laura S. Webb, was endorsed by William Cullen Bryant, who wrote, "It is a favorable sign of returning friendship between the North and the South that the widow of a brave officer in the Confederate Army should lament so passionately the death of one who gained renown in the Army of the Union." For all Americans, the battle was a tragic counterpoint to success in the West that helped to stiffen national resolve for the final conquest of the wilderness.

In so far as the winning of the West required the defeat

CHARLES M. RUSSELL
Indians on a Bluff Surveying
General Miles' Troops
Undated. Oil on canvas, 23 × 35½"
Gift of William E. Weiss
22.71

When Charles M. Russell painted a history painting related to the exploration or settlement of the West, he usually painted it with Indian people as the primary focus. This painting refers to one of the incidents in the Sioux wars of the period 1876–1879, when Nelson Miles pursued the Indians in Montana.

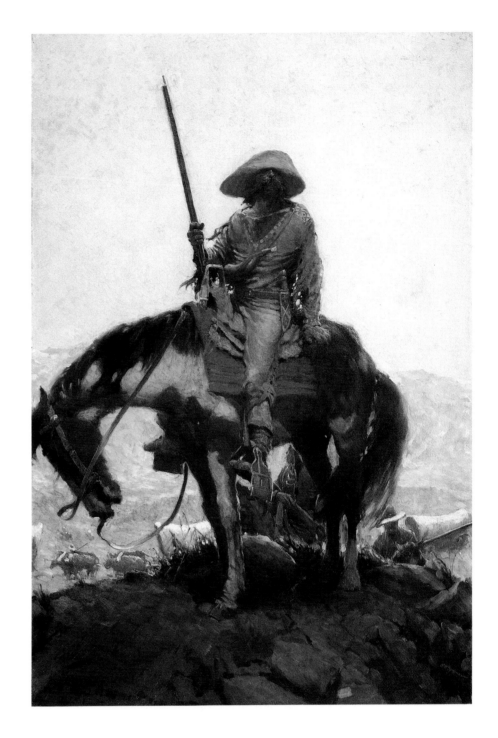

HARVEY T. DUNN
(1884–1952)
The Scout
1910. Oil on canvas, 36¹/₈ × 24¹/₈"
5.77

A native of South Dakota (he was born in a sod house there), Dunn painted prairie subjects for book and magazine illustrations. After an apprenticeship with Howard Pyle, Dunn became a student of the master illustrator and teacher. *The Scout* was on the cover of *Outing* magazine in 1910.

and displacement of the Indian, the cavalry assumed symbolic importance, less for the predominant drudgery of its peacekeeping role than for a few highly visible and emotionally laden encounters. In the popular imagination, the frontier army is still the focal point of America's nineteenth-century policy toward the Indian—a battlefield colored with both glory and disgrace.

Schreyvogel was fascinated with military life and the West. As a young artist, he visited Buffalo Bill's Wild West expositions, sketching the Indians, soldiers, and cowboys behind the scenes. *The Summit Springs Rescue* shows Buffalo Bill in battle on July 11, 1869, trying to save two frontier women who were kidnapped in Nebraska by Chief Tall Bull and his Cheyenne Dog Soldiers. Cody led General E. A. Carr and the Fifth Cavalry in pursuit of the kidnappers. Through a series of clever maneuvers, Cody tracked the Indians to northeastern Colorado and charged the Cheyenne camp. In the resulting skirmish, one of the women was killed and one was rescued.

Upon learning of the artist's intentions, Cody wrote to Schreyvogel, "I know you will make a great picture of the Battle of Summit Springs, and some time I want you to paint the other fights I was in."

The Battle of the Little Bighorn captured the attention of America. Dunton's painting features the Sioux warriors as the primary focal point rather than Custer's soldiers. In choosing this format, Dunton may have been following the lead of Charles M. Russell. In Dunton's painting, however, the focus on the Indian may be due less to an interest in portraying history from the Indian's point of view and more to a fascination with painting the picturesque Plains Indians with their warbonnets and painted ponies.

The ironies of America's "Indian policy" and of the Indian peoples' response to it are immediately apparent in this composite photograph. The peace medal lies on top of a pictographic depiction of the Greasy Grass fight, or Battle of the Little Bighorn. This version of Custer's last stand was drawn by a Sioux participant about a dozen years after the battle. Gift of Mr. and Mrs. Robert G. Charles.

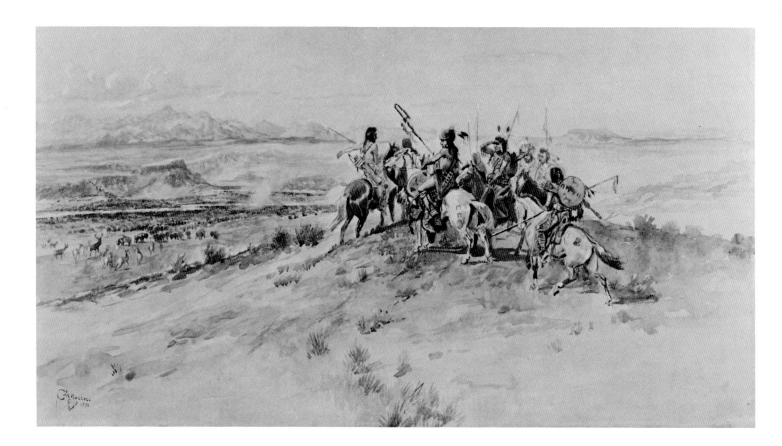

above:
CHARLES M. RUSSELL
Hunting Party
1896. Watercolor on paper, 12³/₈ × 23"
Gift of William E. Weiss
24.73

Painted in the year of his mar-
riage to Nancy Cooper, the *Hunting
Party* is an example of Russell's work
when he was beginning to master the
watercolor medium.

opposite:
JOHN M. STANLEY
(1814–1872)
Last of Their Race
1857. Oil on canvas, 43 × 60"
5.75

When John Mix Stanley painted
Last of Their Race in 1857, he had just
settled in Washington, D.C., after years
of traveling in the West. Beginning in
1842 Stanley journeyed to Indian coun-
cils in Oklahoma, seeking to portray
representatives from the tribes. During
the Mexican War he served as a
draftsman for the Army of the West,
marching through the Southwest to
California. The Pacific Railroad Survey
then took Stanley westward for his final
journey in 1853–1854, when he accom-
panied Isaac Stevens's expedition to
survey a northern route for the rail-
road. He returned to Washington to
prepare illustrations for the printed re-
port. His knowledge that a transconti-
nental railroad could be built must have
influenced his belief that the nomadic
Indian would eventually be pushed to
the edge of the western ocean.

INDIANS, LANDSCAPE, AND
WILDLIFE

Though they had different meanings to those westering souls
who encountered them, the three things inevitably noted
in travel accounts of the West were Indians, the landscape,
and the wildlife. Artists would later find them virtually
inseparable.

It is important to remember that at the time of Lewis
and Clark, when white Americans first penetrated the interior,
Indian people of the Rockies and Great Plains had been ex-
posed directly or indirectly to Europeans for over two hun-
dred years. Trade and cultural contacts had indelibly altered
their ways of life and had changed traditional relationships
among many of the tribes.

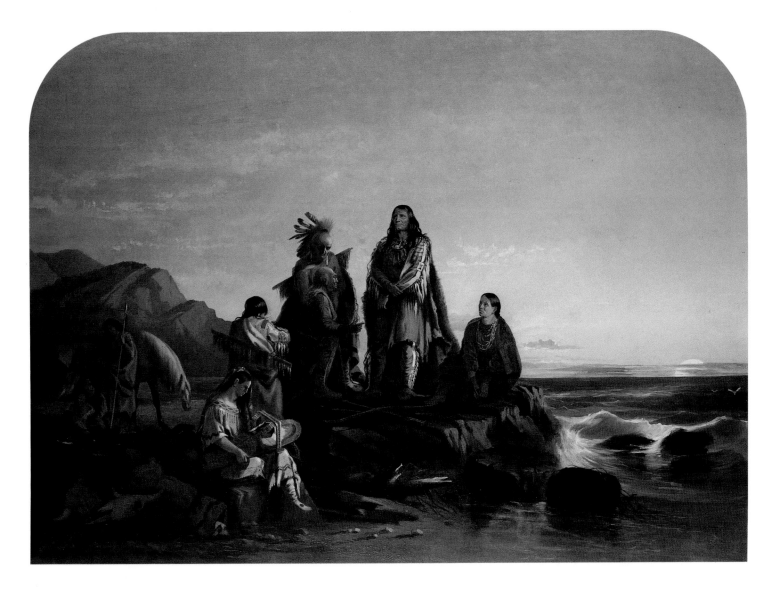

The Comanches and Shoshones of the southern Plains had domesticated the Spanish horse by about 1700, and the Shoshones had introduced the horse to the upper Plains by about 1730. Firearms had reached the Indians of the Great Lakes and eastern Plains at about the same time. Usually the Indians obtained large-caliber trade muskets (such as the long Hudson's Bay musket decorated with brass serpent and the company's proof marks on *page 96*). Yet while the horse gave the Plains Indian a new mobility, the firearm made him dependent on the trader's powder and ball. They were powerful instruments of change, but other less dramatic commodities were no less instrumental in altering intertribal and Indian-white relationships. European fabrics and glass and metal manufactured goods became available and were popular with Indian people, causing different tribes to vie for control of certain trade routes. The Blackfeet and Sioux were rivals, for example. The Blackfeet had monopolized trade with the Canadian fur companies of the Northwest in the late eighteenth century, while the Sioux controlled trade along the Missouri.

A Sioux war club, with characteristic carved markings and brass tacks as decoration. Gift of the William R. Coe Foundation.

opposite top:

A Sioux bow case made from deer hide and decorated with glass beads.

opposite bottom:

These Northern Plains pipes were made in the late nineteenth century from the reddish pipe stone called catlinite. Known as calumets, or "peace pipes," they were passed around on ceremonial occasions as an expression of fellowship.

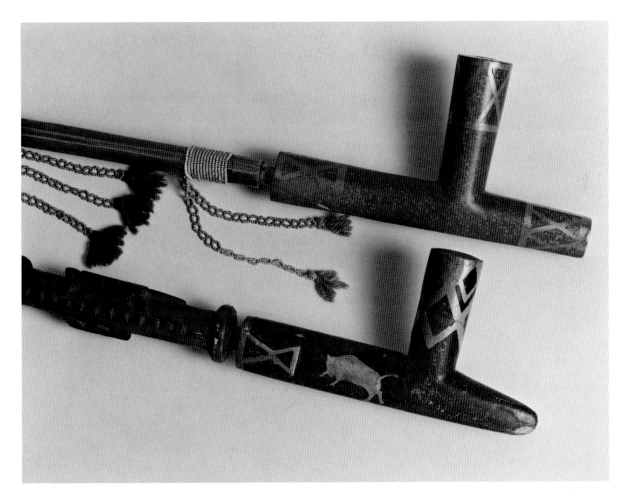

By the time Lewis and Clark encountered them, the Indians of the Plains had established the patterns of life and art that would become familiar to nineteenth-century Americans. Artists, war correspondents, members of peace missions to Washington, pulp novelists, and Wild West troupers reinforced the stereotypical notion of a single, homogeneous Plains Indian culture; whereas in reality there were twenty-seven or more distinct tribes speaking mutually unintelligible languages. While there was a cross-fertilization of decorative styles among Indian tribes, the artistic adornment of both practical and ceremonial objects, such as clothing (*page 110*) or saddles or parfleches, was varied and distinctive.

For most Americans, their understanding of the Indian people was based on visual and emotional cues. Usually Indians were represented either as colorful but primitive and bloodthirsty warriors, or they were portrayed in sentimental terms as innocent, noble savages probably doomed to extinction. Until the end of the Plains wars and the official closing of the frontier in 1890, the Indian was a fixture of the Western landscape. The scenic and geological wonders of the landscape—the prairies, canyons, mountains, deserts—were wild and exotic. So were the Indians. Indian people or Indian things appear frequently in pictures that are otherwise of the landscape. They are often as necessary to the exotic setting as the flora. In narratives of the overland trails, Indians are commonly described as "present" though "unseen."

The paradoxical views of the West—perceived alternately as a barren void and a land of abundance—are paralleled by the perception of the Indian as both debased and noble. In fact, the barrenness of the landscape was frequently intended to mean uncultivated—that is, the Indian had not farmed or "improved" it. One traveler to Colorado in 1859 described his vision of a time when not only would the land be made productive but also when "the poor old Indian shall be closely girted with bands of white brothers who shall teach him by example the nobility of toil and morality."

Barren or lush, the Western landscape was indeed a landscape of wonders. The greatest wonder was its size. Distances were so great, the prairies so vast, and the mountains so high that many of the explorers and surveyors commissioned by the U. S. government spent their entire careers defining the West.

Lieutenant Zebulon Pike was the first American to explore what is now Colorado, which he reached in 1806, only months after Lewis and Clark returned from the wilderness. The power of the discoverer to excite the public imagination is illustrated by a pair of important errors promulgated by

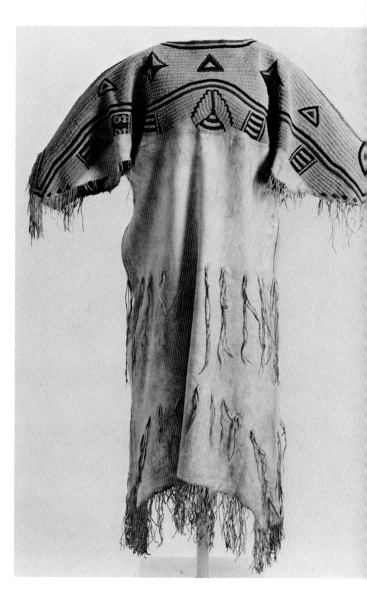

This intricately beaded deerskin dress is evidence of the presence of art in the lives of Plains Indian people. Without a tradition of creating art for its own sake, they nevertheless transformed ordinary garments as well as ceremonial attire into objects of beauty.

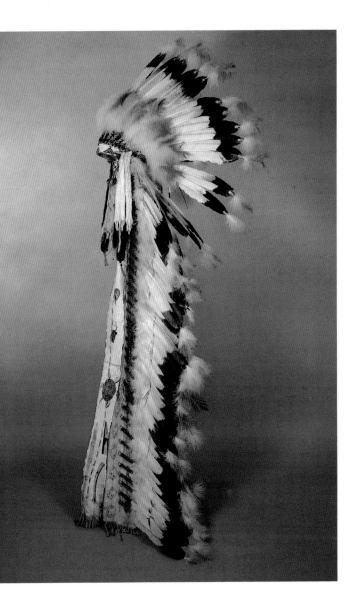

In the heroic societies of the Plains, feathers and paint made the warrior dangerously conspicuous, but they made his boldness more conspicuous as well. Spectacularly long eagle-feather warbonnets such as this one were worn by successful warriors but were not necessarily indicative of rank or political influence.

Pike that for a long time inhibited a real understanding of the interior West. Most important, he characterized the Plains as the "Great American Desert," a concept that discouraged settlement for generations. In addition, he underestimated the vastness of the northern Rockies and Plains, which led some to fear that New Mexico was vulnerable to invasion from Canada!

One of the great events for the American understanding of the Western landscape was the attachment in 1820 of two artists to an expedition led by Major Stephen Long. Samuel Seymour and Titian Ramsay Peale recorded Long's trek to the Rockies and southern Plains. Thereafter, all of the great missions to the West—the expeditions of Fremont, the Pacific Railroad surveys, the great post–Civil War surveys—were accompanied by artists.

By the late 1860s, wartime advances in field photography had diminished the documentary role of landscape artists but not their power as propagandists. Americans were just beginning to grasp their common responsibility to protect the public lands. The establishment of Yellowstone National Park in 1872 and the early vigor of the national parks movement can be credited in part to artists such as Thomas Moran who could capture wildlife, geological detail, and visual splendor that the camera missed (*page 86*). Indeed, the American conservation movement owes much to the artists and writers who created such visions of abundance in the mid-nineteenth century and then so eloquently lamented its passing. It was when wildlife began to disappear that public attention first focused on the limits of natural resources.

From the earliest settlement of North America, Europeans wrote with astonishment of the teeming animal life, which was abundant even on the so-called barren prairies. The disappearance of the beaver from the Eastern seaboard caused little concern; the extinction of the great herds of buffalo was officially encouraged. Americans were (and to a great extent still are) motivated in their management of nature by a belief in inexhaustible resources.

The hunter is indelibly linked with the image of the West. Many of the pathfinders and most of the famous frontiersmen established their reputations as hunters—Boone, Crockett, and Cody, for example. In the middle of the nineteenth century, Western safaris were fashionable for American and European sportsmen. Americans such as Theodore Roosevelt and George Bird Grinnell found fulfillment in sport hunting and identified themselves with the West.

The sport hunters were the first white Americans to call attention to the diminishing numbers of wildlife. "The big

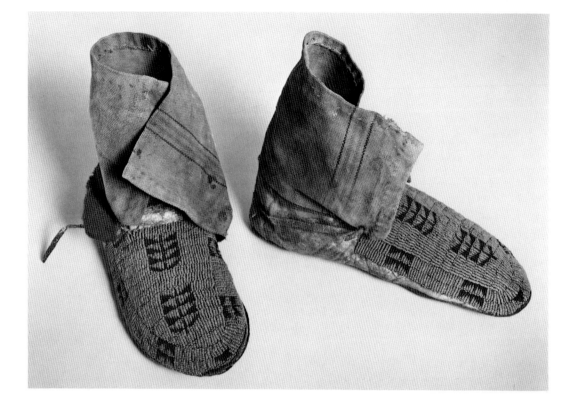

game is fast disappearing," Cody once wrote from Wyoming to an Eastern friend. The buffalo was close to extinction by the mid-1880s, a plight that Albert Bierstadt effectively linked with the end of heroic Plains Indian cultures (*page 40*). At the end of the century, deer and ducks were almost gone from many of the eastern woodlands, and the last of the once seemingly numberless passenger pigeons died in a zoo in 1914.

While hunters were pressing for game laws, the work of artists such as Bierstadt reminded Americans of the recent past when the pristine mountains and Plains were visited only by Indians and wildlife. Roosevelt, Grinnell, and others created organizations such as the Boone and Crockett Club, which was founded in 1882 to promote responsible hunting and conservation. Within a decade, beginning with the forest lands around Yellowstone Park, the government began to set aside wilderness areas and wildlife breeding grounds to be preserved for the public trust.

As American Indian people today reassert their cultural identities, reviving nearly lost arts and skills and assuming greater control of their lives and resources, they remind all Americans not just of the errors but also of the vitality of their Western past. And as debates arise—as they have for a century—over the use of public lands, Americans are reminded again and again of their common stake in the West.

Frederic Remington owned this pair of beaded Crow moccasins, which have strips of red tradecloth around the side and back and were made about 1870. He arranged the moccasins with other Indian objects for a pen and ink drawing, *In the Lodges of the Blackfeet*, which was published in *Harper's Weekly* on July 23, 1887.

THE COWBOY

No American symbol is so easily recognized as the cowboy. With his broad-brimmed hat, his pointed high-heeled boots, his chaps and spurs, and other trappings, the cowboy was frequently called the knight of the prairie. He was considered to be the culmination of the chivalric tradition (*page 78*). But it was not so at the beginning.

By the time of the first great Western trail drives of the 1860s, the Mexican *vaquero* had been working cattle for nearly 350 years. Almost all of the techniques and equipment of the cowboy have Mexican origins. California and Texas were the centers for Western cattle raising until the 1870s, but while the Californian ranch hand's style remained faithful to his Mexican origins, the Texan ranch hand evolved quite separately into the familiar cowboy of the Plains and Rockies.

After the Civil War, the demand for beef in the East could not be satisfied by local production. At the same time, there were thousands of wild longhorns grazing in Texas. Rounding them up and herding them to markets was dangerous, dirty, low-paying work. Cowboys were likely to be young-

This plaited straw sombrero decorated with gold thread is from Frederic Remington's collection. The cowboy owes much to the vaquero of Mexico. A lot of his lingo, in particular, is derived from Spanish words. In fact, his nickname "buckaroo" is an anglicization of the word *vaquero*. And if John B. Stetson's name had not become so firmly attached to his product and others like it in the 1880s, we might still call cowboy hats *sombreros*.

sters or men who found it difficult to get other work—farm boys escaping the plow, blacks, and former Confederate soldiers.

"Most all of them were Southerners and they were a wild reckless bunch," wrote cowboy Teddy Blue (E. C. Abbott). "For dress they wore wide-brimmed beaver hats, black or brown with a low crown, fancy shirts, high-heeled boots, and sometimes a vest." When this gear was combined with homemade duds and Mexican trappings, the cowboy presented a colorful picture (*page 52*).

Originally, their wildness branded them as ruffians. They worked and played in tightly knit groups, which seemed like gangs. As late as 1916, the word "cowboy" would be used in the Eastern press as a synonym for a Western gangster. It was not until the 1880s, when the days of the open range were almost gone, that the public image of the cowboy improved.

In 1883, Buffalo Bill put cowboy performers in the public eye. The first cowboy "star"—Texan Buck Taylor of Buffalo Bill's Wild West show—became the first cowboy hero of the dime novel. His size (six feet six inches), skills, and gentlemanly bearing made him acceptable company even in Philadelphia (where he eventually went to live).

The cowboy's uniform took shape in the 1880s as well. The high-crowned Stetson, chaps, boots, and cuffs became customary. Teddy Roosevelt, who had bought his Dakota ranch in 1883, wrote in 1888 of the cowboys he knew, "with their jingling spurs, the big revolvers stuck in their belts, and bright silk handkerchiefs knotted loosely round their necks over the open collars of the flannel shirts." Roosevelt, a staunch patron of Frederic Remington and friend of Buffalo Bill and Owen Wister, also contributed greatly to the image of the cowboy, calling him "the rough-rider of the plains, the hero of rope and revolver." He saw the cowboy as the noble heir to the frontiersmen of Kentucky and Tennessee (*page 51*).

In the 1890s, a number of factors assured the cowboy's place in the American pantheon. A severe depression and rapid urbanization contributed to a nostalgia for the "wild" West and a professed admiration for individualism, especially the rugged individualism the cowboy seemed to embody. Romantic and chivalric values were prized by a sentimental public, leading Mark Twain to lampoon them in 1889 in *A Connecticut Yankee in King Arthur's Court.* But even Twain was captivated by the breezy qualities of the American cowboys, so inimical to the corruptions and complications of politics and business. Where once the cowboy's wildness was decried, now it expressed his freedom and his spirit of fun.

In his appearance, the American cowboy combined the functional and the showy—especially after his public image was forever established by Wild West shows and Hollywood Westerns. The cowboy embellished whatever he could. The Colt .45 shown here is fitted with ivory grips. The chaps are made from the hide of an Angora goat. Engraved nickel silver dresses up a pair of iron spurs. The saddle, modeled by the George Lawrence Company of Portland, Oregon, is gracefully cut and tooled, and the saddle blanket hints at the cowboy's Mexican origins.

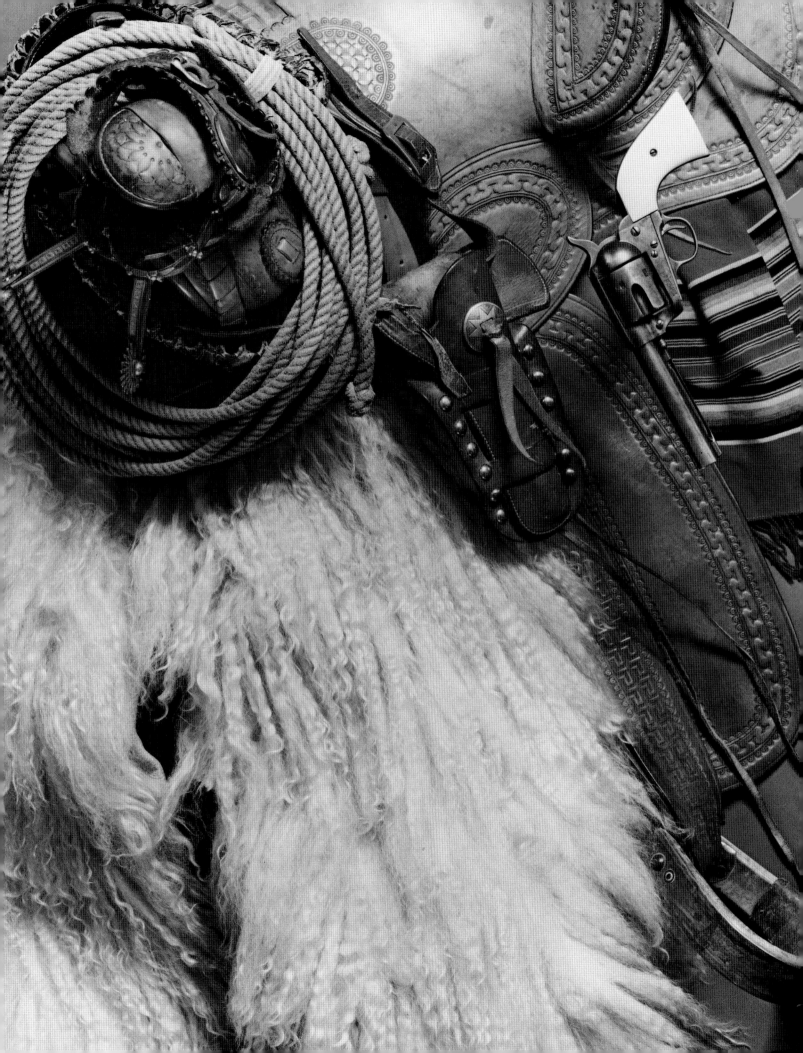

Furthermore, the range was being tamed. In 1889 and 1890, the "cowboy" territories—the Dakotas, Wyoming, Montana, Idaho, and Washington—achieved statehood. In the next decade, books by and about cowboys became best sellers. Dude ranching was born. The rodeo developed its now-familiar program. At a time when immigrants from abroad poured into the cities and the wealthy built castles on the seacoasts to imitate the homes of European nobility, the West seemed to be unique, the most distinctly American part of the United States—and the cowboy was its most distinctly American denizen.

Frederic Remington and Owen Wister teamed up to formulate what amounted to a theory of cultural evolution with the cowboy on top. The most influential written expression of the ideal was Wister's *The Virginian*. By the turn of the century, the cowboy exemplified by Wister's hero had become a symbol of the "winning of the West." In his mythic persona, he united Northerner and Southerner and became an exemplar of the "more American" type that Jedediah Morse had prophesied. He represented the best in all Americans in his independence, his honesty, his modesty, and his courage.

Just as the United States began to take an active role in international affairs, the cowboy set an example by refusing to be pushed around and by coolly staring down evil with the words, "when you call me that, smile."

A vaquero jacket made in about 1880 and owned by Frederic Remington. Gift of the William R. Coe Foundation.

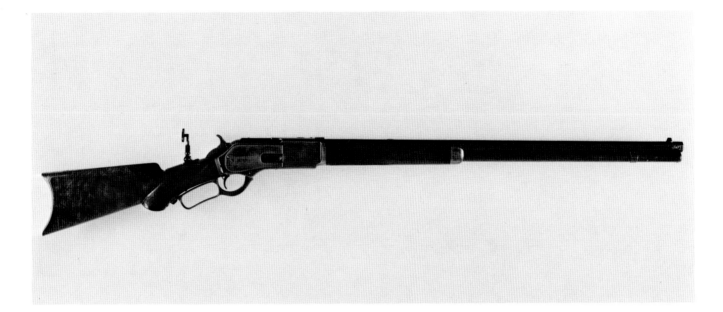

The model 1876 Winchester was the third type in the company's line of distinguished guns that "won the West." This deluxe sporting rifle was designated "One of One Thousand," which means that Winchester's gun-makers felt it was of exceptionally fine quality.

The model 1876 was designed to fire more powerful cartridges than its predecessors, and it became the favorite big-game hunting rifle of sportsmen, including Theodore Roosevelt.

HEROES

The earliest American wilderness warriors were strictly local heroes; the first to become a national hero was Daniel Boone. Though famous for his exploits on an eastern frontier, Boone died west of the Mississippi in 1820. It is easy to picture him facing death the way James Fenimore Cooper's frontiersman, Natty Bumppo—Hawkeye—had: propped up in a chair beside his Missouri cabin, his sightless eyes fixed on the prairie sunset. Boone, at least the Boone of legend, is the model that helped define subsequent generations of Western heroes— mountain men, explorers, scouts (including Buffalo Bill), cowboys, lawmen, and even some of the outlaws.

There were archetypal events and movements, each of which was a step in the great Western epic, each of which can evoke strong images of the frontier West, and each of which spawned characters who are heroic types in their own right. These include the Pony Express (*page 124*), the overland trail, the gold rush, and the transcontinental railroad. There are also icons or popular symbols connected with events or heroes that have the evocative power to stand alone, independent of narrative. Some of these icons include the Colt six-shooter, the lever-action Winchester rifle (*page 117*), the stagecoach, the covered wagon, the buffalo coat, and the war-bonnet (*page 111*).

Buffalo Bill's Wild West and Pawnee Bill's Far East. Brooklyn, 1909. Photograph by Stacy

At the left, with his "Far East" contingent, stands Gordon W. "Pawnee Bill" Lillie. Standing beside Buffalo Bill at left center and wearing woolly chaps is Cy Compton, King of the Cowboys. Also shown are U.S. cavalrymen in plumed helmets, Indians, cowgirls, cowboys, the Devlin's Zouaves drill team, Mexican vaqueros, and William Sweeney's famous cowboy band.

opposite:
FREDERIC REMINGTON
Buffalo Bill in the Spotlight
1899. Oil on canvas, 27¼ × 40"
23.70

Remington had a long association with his friend William F. Cody. He visited Cody's Wild West exhibitions on a number of occasions, using the visits to sketch Western subjects. Remington produced this painting and several others for a biography of Cody, *Last of the Great Scouts*, written by the Scout's sister, Helen Cody Wetmore, in 1899.

The true hero, the heir to Boone, was above all a lone agent. He possessed great courage, special Western skills such as marksmanship and horsemanship, an intuitive knowledge of nature, some cunning, and great hardihood. He was rugged and self-reliant, phlegmatic, a natural leader, and chivalrous but undomesticated. It is usually overlooked that he very likely was working for somebody else—a fur or land or cattle company, the government, or the railroad. Mountain men—the pathfinders, at least—fit the heroic mold. A variety of others who probably would meet most expectations include Kit Carson, Jim Bridger, the Wister cowboy, Elfego Baca, Indian agent Tom Jeffords, photographer Timothy O'Sullivan, and naturalist John Muir.

A number of outlaws, some of them cutthroats and common bandits, have also been treated in regional folklore as heroes. A few have even grown in legend to overcome their criminal or parochial stigmas and become heroes of Western myth. Wars and cultural clashes were spawning grounds of the outlaw hero. Train robber Jesse James emerged from the border conflicts of the Civil War with a Robin Hood reputation. Billy the Kid was revered by many who pictured him as a champion of the Mexican-American lower classes of New Mexico. Both James and the Kid benefited from biographers who emphasized their Boone-like heroic qualities. Sufficient domestic qualities were attributed to both men to make their deaths seem particularly brutal, even martyrlike.

By contrast, few lawmen have entered the American pantheon. Many, like the "Three Guardsmen" of Oklahoma—Bill Tilghman, Heck Thomas, and Chris Madsen—are revered locally. But generally the lawman—the sheriff or marshal, the Texas Ranger, the Canadian Mountie—is unnamed except in fiction. Charles Russell's *When Law Dulls the Edge of*

Chance illustrates the necessary qualities for an officer of the law (*page 60*). The Mountie is self-reliant, a lone agent who takes no unnecessary chances but still must rely for his safety and success on the respect he engenders among the hostile or indifferent.

James B. "Wild Bill" Hickok, even in his lifetime, represented for the American public the ambiguity of good and bad in the American West. His qualities of courage and stamina and self-reliance were legend. His conduct in combat was cool and valorous. He served as a lawman in lawless Western cowtowns. But Hickok killed too often, perhaps, and the justice of some of his kills was open to question. His legendary murder assured him a place in American myth—but as a symbol of violence as much as heroism. The reputations of other sometime lawmen, such as Wyatt Earp, wax and wane with the Hollywood retellings of their lives and were not truly rooted in America's Western myth.

Some events are legendary in themselves, in part because participants are nameless and represent the heroism of the common man and woman. For example, the Pony Express lasted just eighteen months. It originated as a publicity stunt, failed to accomplish its goal—to secure a mail route for the firm of Russell, Majors, and Waddell—and bankrupted the three partners. Through Mark Twain's classic notice of it in *Roughing It*, and Buffalo Bill's reenactment of it in the Wild West shows, the Pony Express was remembered, especially for the fearlessness, skill, and endurance of its young riders. In the popular imagination it bears additional significance as a tool of American unity. Many have credited the rapid transmission of news in 1860 and 1861 for California's commitment to the Union.

The Oregon Trail is an indispensable chapter in the winning of the West, for in the end the West was conquered by the pioneers who built farms and towns. The image of the wagon train toiling across the Wyoming deserts has come to stand for all of the sodbusters and homesteaders, even those who came by railroad and bought their farms from land agents. The men and women who settled the Great Plains were, as Ole Rölvaag described them in his classic novel of the prairie, "giants in the earth."

In fact, one of the strongest and most enduring symbols of the Western epic is the pioneer woman, captured so poignantly by W. H. D. Koerner in *Madonna of the Prairie* (*page 77*). The other side of chivalry in Victorian America was the cult of true womanhood. Women were thought to be physically and emotionally weaker but morally stronger than men.

The soft, oversized Stetson, the high-backed, slick-fork Collins and Morrison saddle, the beaded buckskin jacket with a colonel's eagle shoulder boards—these are as characteristic of Buffalo Bill as his moustache and goatee. Cody was a trendsetter. His gear and get-up were adapted from the tools of the flamboyant frontier scouts, and they became indispensable trademarks for any showman who wanted to be taken seriously as a Westerner.

They were the civilizers, the bearers of virtue and culture. The Victorians felt that if the westering experience was to have lasting meaning, the meaning would be embodied in the domestic and moral values established by the pioneer women.

The gold rushes, particularly the 1849 rush to California, were cataclysmic events. They thrust thousands of men —and a very few women—into primitive and violent settings, eliciting the extremes of human behavior, and engendering a few lasting symbolic characters. First, of course, is the lone prospector panning for gold or digging a claim (*page 79*). No matter that most of the men in the gold fields became gang laborers for larger mining companies or marginal workers in the camps or towns. Fortune-seekers believed in the efficacy of the self-reliant individual.

The second great type in the gold fields was the prostitute or camp follower, exemplified by Calamity Jane, who risked all as an "angel of mercy" to minister to the sick during the frequent epidemics. Death from sickness was so common in the boom towns and along the emigrant trails that the cholera epidemic may almost be said to be another archetypal event.

The Western hero who epitomized the narrative myth of the winning of the West was W. F. "Buffalo Bill" Cody. He also did more than any other nineteenth-century figure to bring the story to the public through an easily assimilated form—the Wild West show (*page 118*).

As a boy on the Plains, Cody was on hand for the great events—the emigrant wagons, the Pike's Peak gold rush, the Pony Express, the border wars. He even spent a season as a trapper. He participated in the building of the transcontinental railroad, especially as a particularly daring and skillful professional hunter providing meat to the railroad workers. He participated in the Indian wars as one of the flamboyant fraternity of civilian scouts, winning a Medal of Honor along the way. He arranged, with George A. Custer, one of the most celebrated excursions of the century, a buffalo hunt on the prairies for the Grand Duke Alexis of Russia.

Then he took it all to the stage where the narrative elements of the modern "Western" were formulated. Finally in 1883, Cody translated it to an arena show, the Wild West, which was seen by more millions of people worldwide in its thirty years than any other single entertainment.

Cody wanted to be remembered as an entrepreneur and capitalist who helped civilize the West. Irving Bacon's allegorical oil painting *Conquest of the Prairie* was commissioned for Cody's personal collection (*page 88*). Most people still picture him in his beaded buckskins, seated in a silver-

This Crow Belt ceremony was performed in Madison Square Garden in 1898 by Sioux members of Buffalo Bill's Wild West. During the Crow Belt or Grass Dance, a young dog was cooked, and the meat, a delicacy, was shared by the participants. Sioux chief Iron Tail stands center left.

A lighthearted example of cultural interchange is seen in this 1902 photograph of Wild West personnel playing Ping-Pong while waiting to perform in the show.

mounted saddle aboard a white horse—the quintessential showman (*page 118*). It may be unfair to the man, but it is eminently just to the legend, for it is as a showman that he made his mark by taking his vision of the West to the world.

The traditional American telling of the winning of the West, especially as it has been expressed since the turn of the century in fiction and film, is decidedly ethnocentric. It was not always so. The West of the Wild West shows of Buffalo Bill and others was truly of unity. Blacks, Indians, Mexicans, all played themselves and depicted their parts in the Western past.

For Indians, particularly, it must have been difficult at

ROSA BONHEUR (1822–1899)
Colonel William F. Cody
1889. Oil on canvas, 18½ × 15¼"
Given in Memory of William R. Coe and
Mai Rogers Coe
8.66

Cody took his Wild West exhibition to Paris in 1889. He accepted the invitation of painter Rosa Bonheur to visit her château at Fontainebleau and in turn invited her to visit the Wild West grounds to paint the animals there. In France, Bonheur painted this portrait of Buffalo Bill, which he sent back to America. Later, when he heard his North Platte, Nebraska, home was on fire, Cody was supposed to have wired home the message, "Save the Rosa Bonheur and let the flames take the rest."

times to relive military defeats, but as one Sioux veteran of the Wild West show remarked, "We were told to keep our customs, our language." So the Wild West, devoted to an American narrative of conquest, nonetheless helped provide continuity in the lives of some Indian peoples who were being pressed by the government and reformers to forsake their traditions (*page 122*).

And for the rest of the world? As historian Howard Lamar has noted, the native horsemen from five continents who congregated in Buffalo Bill's Wild West let the whole world participate vicariously in the adventure of America's westward movement.

BIBLIOGRAPHY

Dary, David. *Cowboy Culture: A Saga of Five Centuries*. New York: Alfred A. Knopf, Inc., 1981.

De Voto, Bernard, ed. *The Journals of Lewis and Clark*. Boston: Houghton, Mifflin Co., 1953.

Fenn, Forrest. *The Beat of the Drum and the Whoop of the Dance: A Biography of Joseph Henry Sharp*. Sante Fe: Fenn Publishing Co., 1983.

Goetzmann, William H. *Exploration and Empire*. New York: W. W. Norton and Co., 1978.

Hassrick, Peter, Ron Tyler, Carol Clark, Linda Ayres, Warder H. Cadbury, Herman J. Viola, and Bernard Reilly, Jr. *American Frontier Life: Early Western Painting and Prints*. New York: Abbeville Press, 1987.

Hutchinson, W. H. *The World, the Work, and the West of W. H. D. Koerner*. Norman: University of Oklahoma Press, 1978.

Novak, Barbara. *Nature and Culture: American Landscape Painting, 1825–1875*. New York: Oxford University Press, 1980.

Reiger, John F. *American Sportsmen and the Origins of Conservation*. New York: Winchester Press, 1975.

Russell, Don. *Lives and Legends of Buffalo Bill*. Norman: University of Oklahoma Press, 1960.

Samuels, Peggy, and Harold Samuels. *Frederic Remington: A Biography*. Garden City: Doubleday and Co., Inc., 1982.

Smith, Henry Nash. *Virgin Land: The American West as Symbol and Myth*. Cambridge, Massachusetts: Harvard University Press, 1950.

Trefethen, James B. *An American Crusade for Wildlife*. New York: Boone and Crockett Club/Winchester Press, 1975.

The famous Pony Express lasted just eighteen months and never earned a government mail contract. Western express agencies used their own stamps rather than Post Office issues and cancellations. This envelope was delivered in 1861. Mr. and Mrs. R. G. Bowman Collection.

Trenton, Patricia, and Peter Hassrick. *The Rocky Mountains: A Vision for Artists in the Nineteenth Century.* Norman: University of Oklahoma Press, 1983.

Truettner, William. *The Natural Man Observed: A Study of Catlin's Indian Gallery*. Washington, D.C.: Smithsonian Institution Press, 1979.

Tyler, Ron, ed. *Alfred Jacob Miller: Artist on the Oregon Trail.* Fort Worth: Amon Carter Museum, 1982.

Unruh, John D. *The Plains Across.* Urbana: University of Illinois Press, 1979.

Utley, Robert M. *The Indian Frontier of the American West 1846–1890.* Albuquerque: University of New Mexico Press, 1984.

Vandiveer, Clarence A. *The Fur Trade and Early Western Exploration.* Cleveland: The Arthur H. Clark Co., 1929.

Washburn, Wilcomb E. *The Indian in America.* New York: Harper and Row, 1975.

Whyte, Jon, and E. J. Hart. *Carl Rungius: Painter of the Western Wilderness.* Salem, New Hampshire: Salem House, 1985.

BIBLIOGRAPHICAL REFERENCE WORKS

Malone, Michael P., ed. *Historians and the American West.* Lincoln: University of Nebraska Press, 1983.

Paul, Rodman, and Richard Etulain, eds. *The Frontier and the American West.* Arlington Heights, Illinois: AHM Publishing Corp., 1977.

Prucha, Francis Paul. *A Bibliographical Guide to the History of Indian-White Relations in the United States.* Chicago: University of Chicago Press, 1977.

INDEX